IMAGES
of America

BATH TOWNSHIP
OHIO

To John Warney,
Jame Anne
Turziello
12/02

I dedicate this book to my father, Lee Turzillo (1909–1977), who brought us to Bath.

IMAGES
of America

BATH TOWNSHIP
OHIO

Jane Ann Turzillo

ARCADIA

Published by Arcadia Publishing,
an imprint of Tempus Publishing, Inc.
3047 N. Lincoln Ave., Suite 410
Chicago, IL 60657

Printed in Great Britain.

Library of Congress Catalog Card Number: 2001094273

For all general information contact Arcadia Publishing at:
Telephone 843-853-2070
Fax 843-853-0044
E-Mail sales@arcadiapublishing.com

For customer service and orders:
Toll-Free 1-888-313-2665

Visit us on the internet at http://www.arcadiapublishing.com

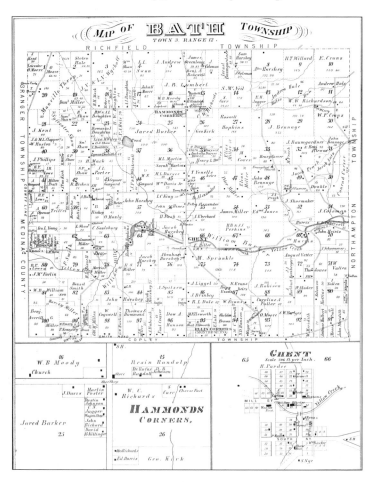

Ceded by Native Americans to the United States in 1805, the entire Western Reserve was in the northeast corner of Ohio. Bath was 12 townships (or ranges) west of the Pennsylvania line and three townships north of the southern Western Reserve boundary. Col. Rail McArthur originally surveyed the township into lots. This is Bath Township as it appeared in the *Tackabury, Mead & Moffett Combination Atlas Map of Summit County*, Philadelphia, 1874. The smaller maps show the business centers of Hammond's Corners and Ghent.

CONTENTS

ACKNOWLEDGMENTS

This photographic history of Bath Township, Ohio, is not definitive. Instead, it is a representation of the hardworking, spirited pioneers and the rough road they traveled to develop this community. The images, mostly from the Bath Township Historical Society and descendants of this persevering stock, are arranged in chapters according to topic, and somewhat chronologically within the chapters. The images span from 1845 to the early 1970s. Every effort was made to represent each family, business, school, etc. of historic significance somewhere in the book.

I could never have put this book together without a number of people who hunted through their closets, dug through their drawers, and dusted off their scrapbooks. I want to thank Mary Ann Krejci and Libby Bauman, both of the Bath Township Historical Society, for helping me dig through the Historical Society's images and providing me with materials to research the photographs, namely the nine "Corners Books." Mary Ann is also responsible for opening doors to other collections.

Early in the search, Mel Knopp and Jan Nagel of the Richfield Historical Society opened the archives for Revere High School photos. Thank you.

I am grateful to Dan and Renada Liddle and their talented crew at Quick Photo for a superb job of providing copies of images. They also connected me with Renada's mother, LaVern Ferguson, who provided historic police photos. Thanks to her as well.

I owe a special debt of gratitude to Susie Wyatt and Phyllis Crile Bortscheller, who entrusted me with originals of their ancestors' photos, Jeff Andrew for much needed pictures of Whitcraft's Store, and Lois J. Eckart for images of the Bath Town Hall. Fire Chief Jim Paulett, Cheryl Jackson, and Pat Rasbitsky tracked down historic photos of the Bath Fire Department, and I thank them for their time. Thanks to Lt. Detective Richard Munsey, former Police Chief Bill Gravis and his son, Dave, for early Bath Police Department photos. A special thank you goes to Randy Bergdorf of the Peninsula Library for hunting up several photos that were valuable to the project. I also thank Jean Falor, Glenn Frese, and Walt Hower for coming up with the right photos at the right time.

Many, many thanks to my friend Marilyn Seguin for giving me the idea for this book and directing me to the right publisher.

Finally, I want to thank my family: my mother, Lucille; and my sister, Mary Turzillo; my son, John-Paul Paxton; and my nephew, Jack Brizzi Jr., for their love and support through this project.

To all of the above, again, heartfelt thanks.

Jane Ann Turzillo
Bath, 2001

INTRODUCTION

Bath Township was sculpted from the Western Reserve after Native Americans ceded the land to the United States at the 1805 Treaty of Fort Industry. The land was surveyed as Township 3, Range 12—or three townships north of the Western Reserve's southern-most boundaries and 12 ranges west of the Pennsylvania line. The surveyors wrote down the name Wheatfield in the original field book, even though the soil wasn't suitable to grow wheat.

It is not definitely known when the first white people began living in Bath, but in 1810 Jonathan Hale and Jason Hammond, both of sturdy and independent New England stock, exchanged their "Old Connecticut" properties, packed their families and belongings into horse-drawn wagons, and forged west to their newly acquired land. The Hales reached their new home in what is now Bath Township on July 13 of that year and the Hammonds arrived two weeks later. These courageous people are recorded as the first legal settlers, but squatters are well documented. The first person to greet Jonathan Hale was Aaron Miller, who had built a cabin on Hale's land. Hale handed over his horse and wagon to Miller in payment for the cabin. The two families parted as friends, and the Hales lived in the cabin until Jonathan and his sons built their three-story brick house. Other squatters that preceded Hale and Hammond included Morris Miller, Moses Latta, Hezekiah Burdit, Gibson Gates, and Moses and Aaron Decker.

The settlement gradually became known as Hammondsburgh. When the township was formally organized in 1818, the question was asked: "What shall it be called?" A droll Jonathan Hale spoke up, "Call it Jerusalem, Jerico, or Bath, or anything but Hammondsburgh." A vote was taken and the township was christened Bath.

Industry sprang up in the form of grist, flour, saw, and woolen mills along the Yellow Creek in Ghent Village (pronounced with a soft g) as early as 1815 to process the farmers' crops. While Bath remained mostly agricultural into the early 1900s, a handful of small population centers or "corners" came into existence within the township. Names like Hammond's Corners, Stony Hill, Ghent, and Ira are still used today, while the names of Hurd's Corners, Little Germany, and Farley's Corners are seldom spoken. Each of these corners built their own schools and churches. Buggy works, blacksmith shops, cheese factories, general stores, and post offices came into being. Soon the canal and railroad brought even more prosperity.

It is possible to trace Bath's heritage through the many historic homes, barns, mills, and stores that are lived in or still operated today. Bath has preserved its history along with its rolling hills, wooded ravines, streams, and country roads.

The historic images for this book are drawn from the Bath Township Historical Society and private collections owned by descendants of Bath's first families. Through these photographs, the reader will meet the pioneers, perhaps ponder their sacrifices, and tour the township's historic buildings.

One
ORIGINAL FAMILIES

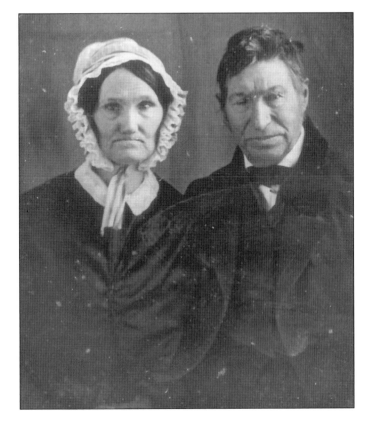

The first "legal" settler in Bath Township was Jonathan Hale, shown in a photograph here with his second wife, Sarah Cozad Mather Hale, taken about 1845. Hale, his first wife, Mercy S. Piper Hale, and their family left their home in Glastenbury, Connecticut, in a wagon with a two-horse team on June 12, 1810. They arrived at their new home on July 13, 1810. (*Western Reserve Historical Society, Cleveland, Ohio.*)

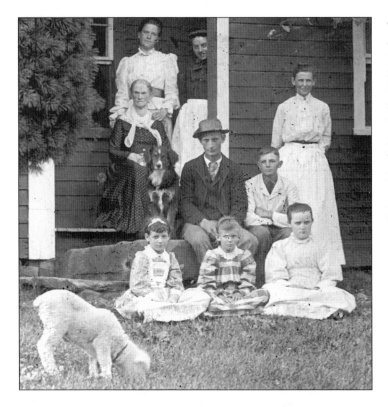

The old woman sitting down in this photograph is Jane Mather Hale who married Andrew Hale on May 12, 1838. She and Andrew had six children. Her son, C.O. Hale (center, in the hat) cared for her in her late years. The other people in the photograph are not identified. (*Western Reserve Historical Society, Cleveland, Ohio.*)

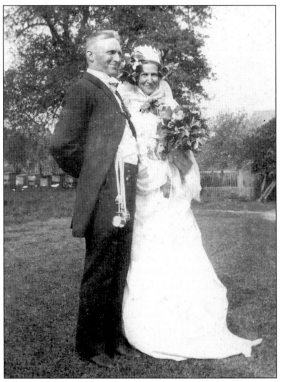

Charles Oviatt (C.O.) and Pauline Cranz Hale dressed in their wedding finery to celebrate their 25th anniversary in 1900. The marriage joined two of the oldest, largest, and most prominent families in Bath. C.O. Hale was the son of Andrew Hale and grandson of first settler Jonathan Hale. Pauline was the daughter of William and Mary Cranz, who came to Bath from Holmes County in 1863.

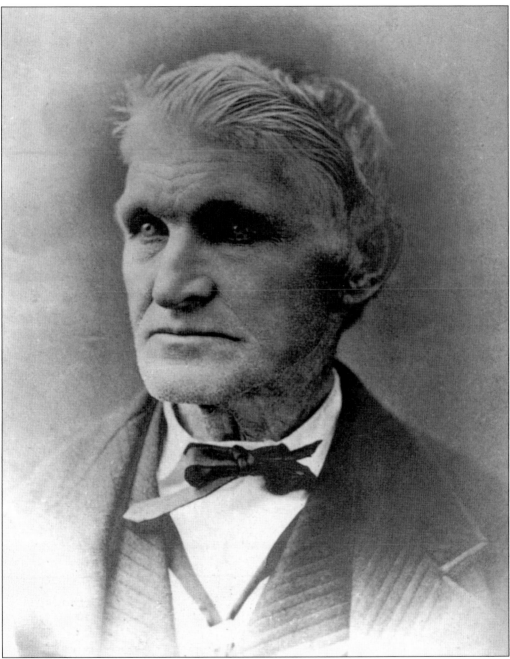

Andrew Hale, son of Jonathan and Mercy S. Piper Hale, was the first white child born in Bath Township on December 5, 1811. The Hales were the first family to settle in what was then called Wheatfield. One of six children, Andrew was educated in the pioneer township schools. In 1825, he and his brothers, William and James, helped their father build a large, brick, Connecticut-style house on their homestead. Andrew was a life-long member of the Congregational Church, a dyed-in-the-wool Republican, a music lover and, by his neighbor's accounts, generous, accommodating, and honest. He lived on the family farm until his death on July 30, 1884.

Grandson of pioneer Isaac Hopkins, who settled in Bath in 1813, Roswell Hopkins established a successful lumbering business. During hard times he lent money to families in need and later opened a bank in Sharon Center. He was also a Justice of the Peace in Bath and a Bath School Board member. He married Ossie Pierson, and they had eight children. This photo of the Hopkins family was taken about 1924. The members of the family, from left to right, are: (first row, seated) Ossie Pierson Hopkins and Roswell Hopkins; (second row) Ruth, Helen, Anna, and Nita; (third row) Cecil, Paul, Howard, and Ross.

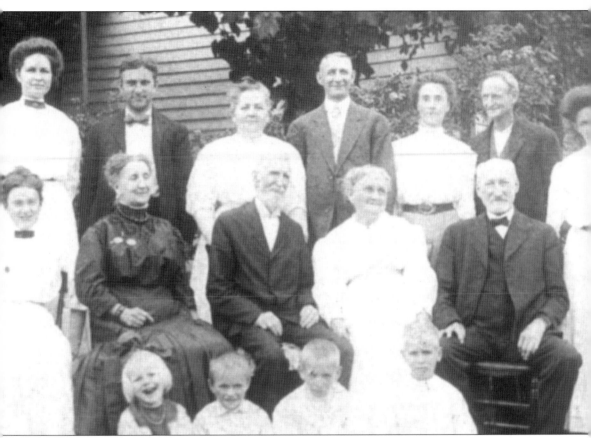

Henry Willet Howe (seated, center) was born in 1828 on the 400-acre Ira farm owned by his father, canal engineer Captain Richard Howe. After graduating from Oberlin College with an A.B. and an M.A. in 1849, Henry ran his father's contracting business while the latter was in California during the gold rush. In 1854 Henry was admitted to the bar and practiced until he bought a business in 1870 that manufactured spokes and axles. Later, he sold this business and raised stock. Politically he was a Whig and an Abolitionist, then a Republican. He served on Akron City Council, the Akron School Board, and was a Justice of the Peace. Henry married Isadore C. Bell. They had four children. This photograph of the Henry Howe family does not identify the members.

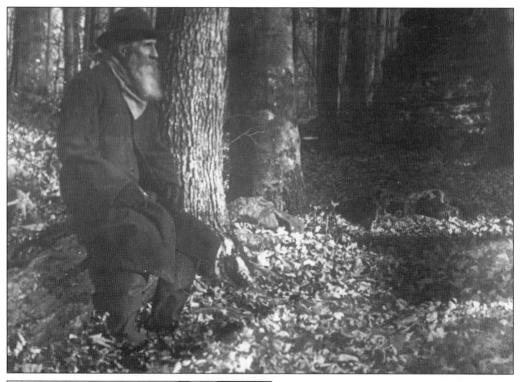

One-year-old Sylvester Pitts Shaw came to Bath from New York in 1832 with his parents, Sylvester and Harriet, and sister, Cordelia. Three years prior, his Uncle Samuel Shaw had established the "Shaw Clan" on 160 acres on "Shaw Street" in Bath Township. Pitts' grandfather, Constant, soon followed the trail to Bath, as did Richard and Philip. At one time every child at Hurd's Corners school was named Shaw. The Shaws donated land for Moore's Chapel Cemetery. In his old age Pitts made toys for children.

Clemen N. Jagger came to Hammond's Corners in 1852 from Richfield. Jagger was well known and respected throughout the area as a fancy buggy and surrey maker. He married Jane Perry, the great granddaughter of Admiral Oliver Perry.

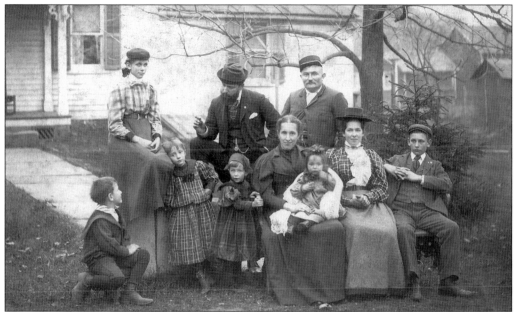

Wilhelm (William) Schumacher and his family lived at Ira in a house (in the background) built in 1839–1840 by William Hale. Wilhelm was the nephew of Akron's "cereal king," Ferdinand Schumacher.

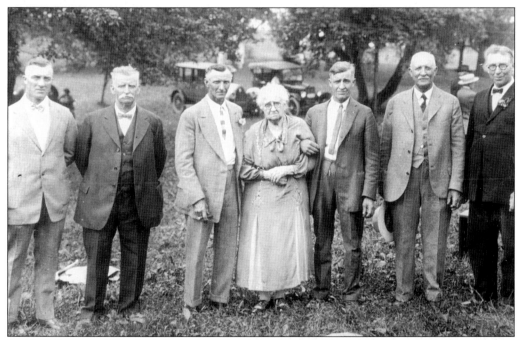

In 1865 Peter and Elizabeth Boltz brought their three children from Pennsylvania to Akron, Ohio, by canal boat, and from Akron to Bath by horse and wagon. They settled on a farm at the southwest corner of Bath and N. Revere Roads. They had eight more children. Peter died in 1896. Elizabeth lived to be 97. She is pictured here with her sons. From left to right, they are Albert, Charles, Sherdon, Elizabeth, Sherman, Tom, and Carl.

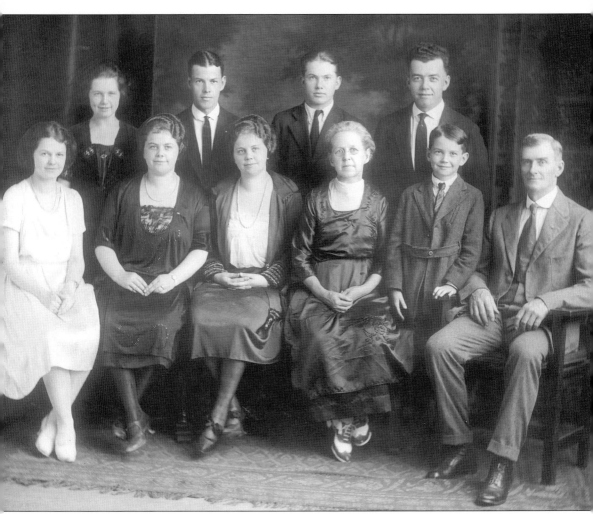

This photograph of the Alonzo C. Alexander family was taken in 1920. Pictured from left to right are: (front row) Gladys Bunnelirside (Bunnel ?), Nellie James, Helen Hale, mother Hattie, Jay Park, and father Alonzo; (back row) Clara Stamfield (Stansfield ?), Perry Howard, Robert, and Clair. Alonzo was born in 1871 in the house his grandfather built on N. Cleveland-Massillon Road. He followed in his father's footsteps by serving as a township trustee and treasurer, and school board member. His wife, Hattie Behmer, was born in Richfield. All eight of their children were born in Ghent, attended the district school, and graduated from Bath High School.

Perry Alexander (1837–1909) was born in Bath. His parents, John and Martha, came to Ghent in 1830 from Lancaster, Pennsylvania. After fighting in the Civil War, Perry owned a small construction company and built many of the fine homes and barns in Bath—many of which are still standing. He was one of the first Bath Township trustees, township treasurer, and Bath school board member.

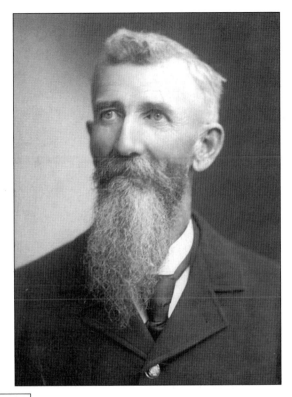

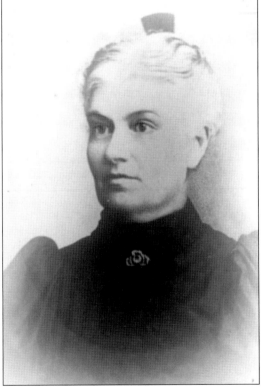

Clara Coffin of Ghent married Perry Alexander. They had five children: Alonzo, John, Wilbur, Belle, and Mary.

Eugene Franz Cranz came to Bath Township in September 1863 when he was a month old. His mother and father raised him and his 12 siblings in Jason Hammond's house. He inherited the 164-acre Ira farm and in 1906 began to raise trees. He became a woodland conservation expert, and his land was known as Pleasant Valley Farm. Sometimes called "the grand old man of the valley," Cranz died at 89.

Nettie Parker was a teacher from Osborne's Corners when she captivated Eugene Cranz with her lovely singing voice at a Grange meeting. They were married in 1893 and went to live on Pleasant Valley farm. The Cranzes had six children. Nettie died in 1939. (*Photo Courtesy of the Peninsula Library and Historical Society, Peninsula, Ohio.*)

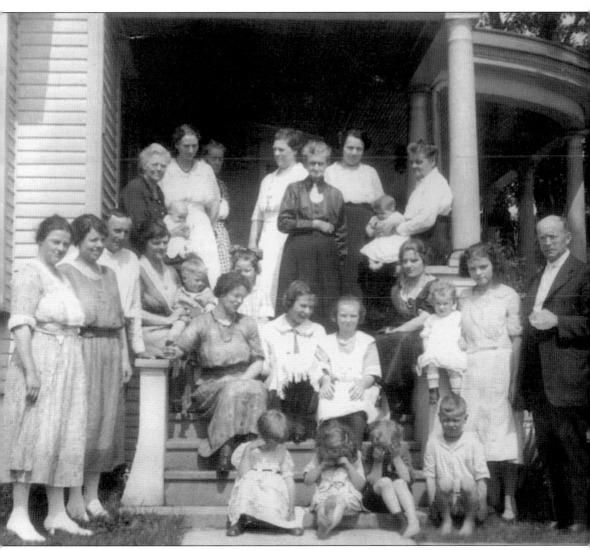

Pierson is a prominent pioneer name in Bath. This photograph, taken about 1928, represents three generations of hard-working Pierson women, whose labors helped to build a community. They are identified on the back of the photo from left to right as: (front row, children) Sadie's daughter Freeman, Mary Ellen Freeman, unidentified, and Ross; (second row, standing) Aunt Sadie Freeman, Aunt Edna, (seated) Aunt Clara Pierson Shade, Nita Edwards, Marjorie Pierson, Janet, (standing) Zing Hopkins, and Doc Smith; (third row) Roswell Hopkins, Aunt Mary Bayles holding Bob, Ruth Freeman, and Mary Pierson; (top) Great Aunt Viola Spears holding baby, Ethel Pierson, Aunt Ann Wycoff, Ossie Hopkins, Great Aunt Lib Spencer, Anna Frasier, and matriarch Alfe Davis Pierson holding Marion. The house belonged to Roswell and Ossie Hopkins. A note attached to the picture reads, "I have no idea why Doc Smith is visiting since little discussion was made about women's problems (in that day). Perhaps it was to talk about children."

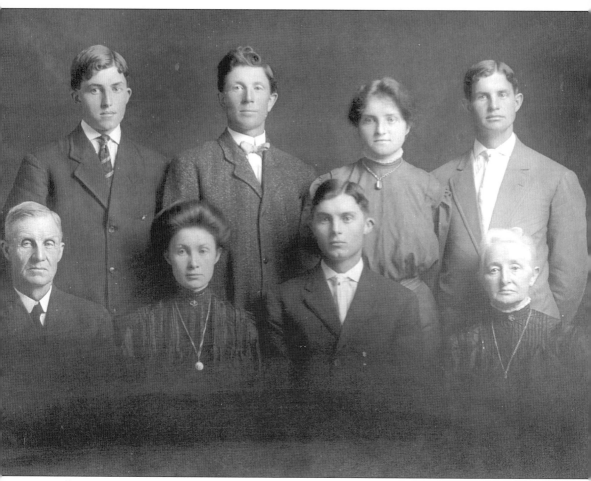

William and Ann Davis came to Bath in 1846 with their seven children. Two more children were born in the township. One son George S. Davis married Jared Barker's daughter Molly in 1873. They had seven children. Six are pictured in this photo. From left to right, they are: (front row) George S. Davis, Mary Davis Hackett, Paul Davis, and Molly Barker Davis; (second row) George Davis, Jay Davis, Anna Davis Kimpton, and Jared Davis.

Eber Shoemaker (seated) was born in 1873 to Charles and Caroline Harris, who died in childbirth. His Aunt Eleanor Harris Shoemaker and uncle, Jacob, adopted him in 1879. He was raised on the family's 123-acre W. Bath Road farm and continued to make it his home after marrying Lillian Miller. Shoemaker was one of the longest-serving township trustees in Bath. The man with him is identified as his brother, Frank Harris.

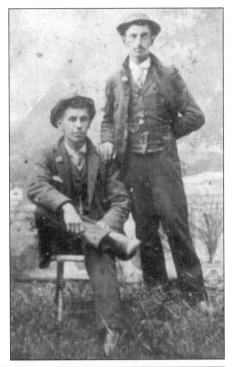

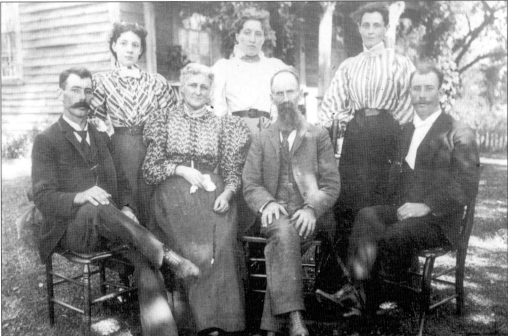

Robert Yates Robinson, a teacher from Wayne County, married Sarah Clapper and took her to Missouri. She became so homesick that they returned after only two years. They bought a farm on Medina Line Road where Robert cut trees and hauled them to Hopkins Mill, so he could use the wood to enlarge the barn. He later sold the farm to his son-in-law, Earl Rockwell, for $50 an acre. This photograph of the Robinsons was taken in 1897.

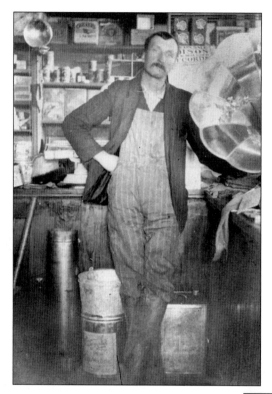

Floyd Lincoln "Lynn" Worden married Amma Zilla Spencer in 1887, and they had two girls, Esther and Ethel. The Wordens lived at Botzum where Lynn was the station agent for the Valley Railroad, then moved to the Spencer farm on N. Medina Line Road south of Bath Road. In 1897 they established a general store and the Worden Post Office in the north end of the house.

Four generations of the Fryman family are pictured here: Joel Fryman (seated) was born in 1836; William Fryman (left) was born in 1859; Rex Fryman (right) was born in 1885; and baby Alleen was born in 1918. William and his wife, Lena, came to Bath in 1884 and bought a farm from Lena's aunt at Stony Hill. They raised cows and horses, which were sold to fire departments and companies that needed horses to pull heavy loads.

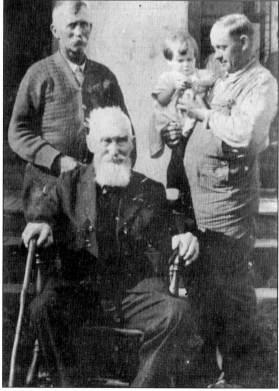

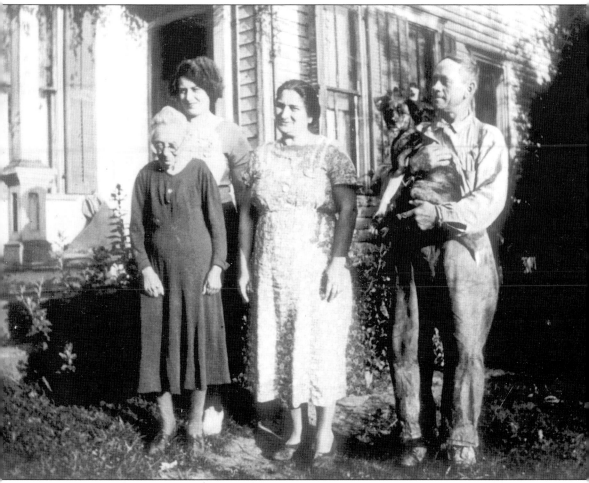

Lena Hubbard (left) was teaching school when she met her husband, William Fryman. Her son, Rex Fryman (right, holding his dog, Pattie), and his wife, Allie (middle), lived on the Fryman farm all their lives. Allie taught at Granger grade school. Rex was a charter member of the Stony Hill Fire Protection Association. Their daughter, Alleen (behind), married Eddie Stein and was the first president of the Bath Township Historical Society.

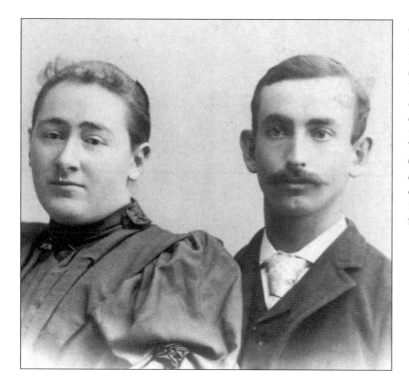

Clyde and Edith Miller owned a farm known as the Clearview on Shade Road. They had six children. Their daughter, Nona, married Harley Boltz. The Millers lost the Clearview during the depression. The next owners developed it into a summer camp for boys.

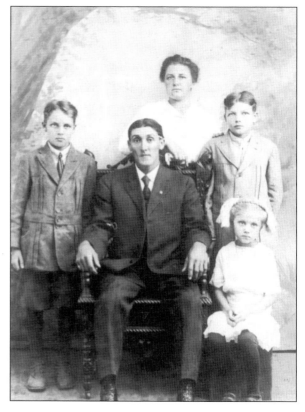

In 1916 Harry and Abby Miller Crile of Ghent had this picture taken of themselves with their sons, Jay and Ford, and daughter, Vivian. Harry Jr., Bob, and Jackie were born after this photo. Jackie died before he was a year old.

Two
HOMESTEADS

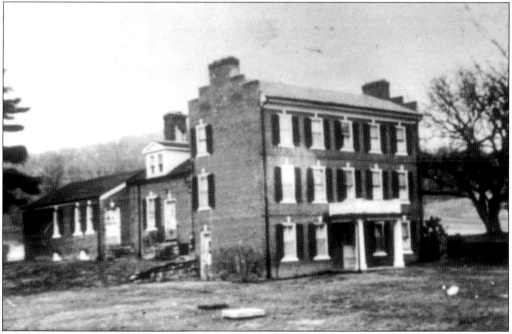

Jonathan Hale and his sons built this house in 1825 with bricks made from clay found on the farm. This Connecticut-style house was home to three generations of Jonathan's descendants—Andrew Hale, C.O. Hale, and Clara Belle Ritchie. Ritchie willed it to the Western Reserve Historical Society in 1955. Today it is part of Hale Farm and Village Museum.

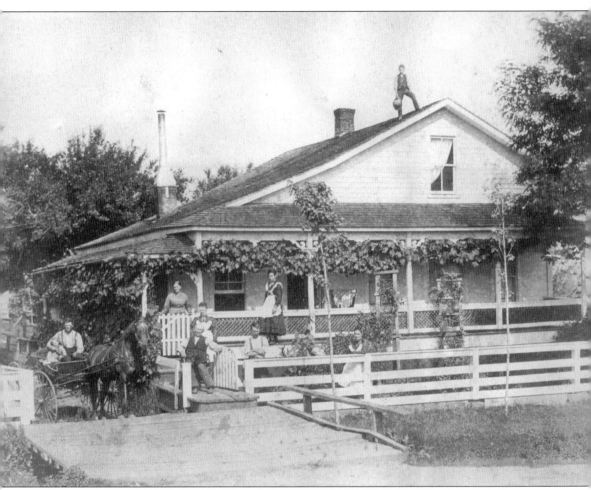

This house was built about 1837 by Frank Pierson in Ghent on Wye Road. Pierson is sitting in the wagon. The man on the roof is believed to be Bert Porter, father of a large family and Roswell Hopkins' favorite sawyer (expert at running the sawmill). Pierson's widowed daughter Viola Spears owned the house. She lived upstairs and allowed Doc (Robert) Smith to move into the downstairs. A very moral lady, Viola made sure the relationship was proper. She bequeathed the house to Smith upon her death. It has been preserved and is now The Bake Shop in Ghent.

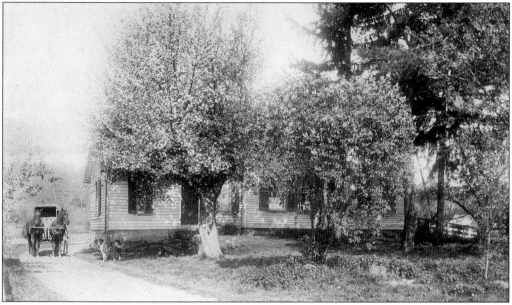

Sylvester and Harriet Parsons Shaw moved to Bath from New York in 1832 and built this house.

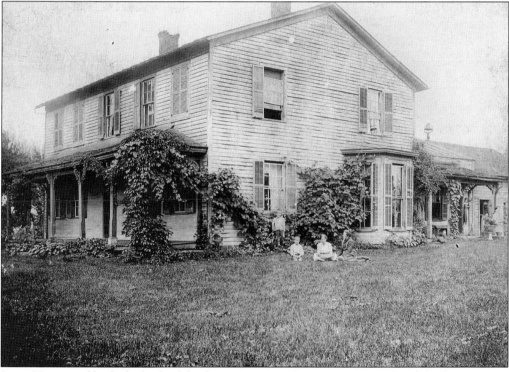

Jason Hammond built the back of this house in 1818. His son Lewis completed the front section in 1828. In 1863 William and Mary Cranz bought the house and 150 acres which surrounded it. It was home to three generations of Cranzes until it passed into the hands of the Cuyahoga Valley National Park in the 1970s.

Clemen N. Jagger's Greek Revival-style house was built in 1855 adjacent to the buggy shop at Hammond's Corners. It was donated to Hale Farm and Village Museum by the Jagger family and moved to Hale Farm from its original site in 1962. (*Western Reserve Historical Society, Cleveland, Ohio.*)

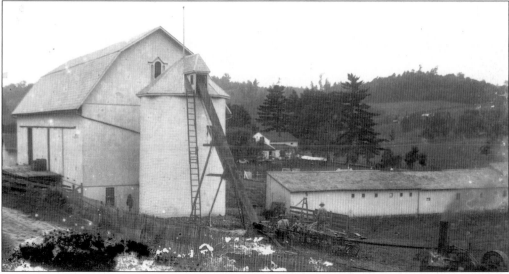

This farm on Oak Hill Road passed through several owners, including William Hale, who built the original house in 1839–1840, Wilhelm Schumacher, and Edward Cranz Jr. The old house burned in 1915 and was rebuilt in the 1920s by Ralph and Doris Cranz Wetmore. This barn was the scene of the first Bath Horse Show. It sits opposite Hale Farm.

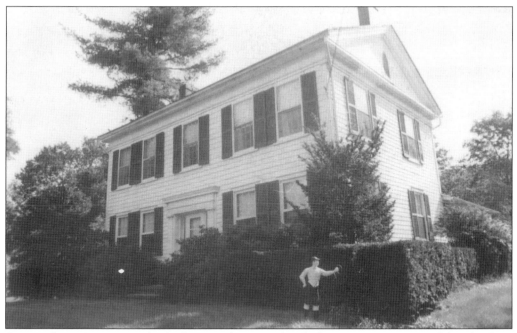

Counterfeiter Jim Brown built this Greek Revival-style house on 300 acres of farmland on Akron-Peninsula Road at Ira. A plaque on the corner of the house reads: "Century House, 1837 (approximately)." After Brown died, his son James Jr. continued to live there until his death in 1889. In 1907 Andrew Bender bought the farm and moved his wife and ten children into the house. Much of the land was sold off through the years, but Earva Bender and his wife, Kathryn, lived on and worked the farm up until their deaths. Now in the hands of the Cuyahoga Valley National Park, the house and its barn are being restored as a bed and breakfast and restaurant.

The John Bennages posed in front of this house that he built on Revere Road. Revere was known as Croton House Road at one time. During the mid to late 1800s, Bennage owned a large portion of land from Cleveland-Massillon Road east to Revere Road. The house later became part of the Harley Boltz farm.

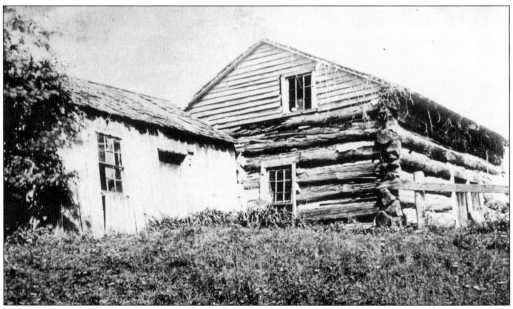

William Barker built this log cabin on Yellow Creek Road in the late 1850s. His son Jared, born in 1861, inherited this half of the land along with Barker's Mill. William's older son Lanson inherited the land across the street.

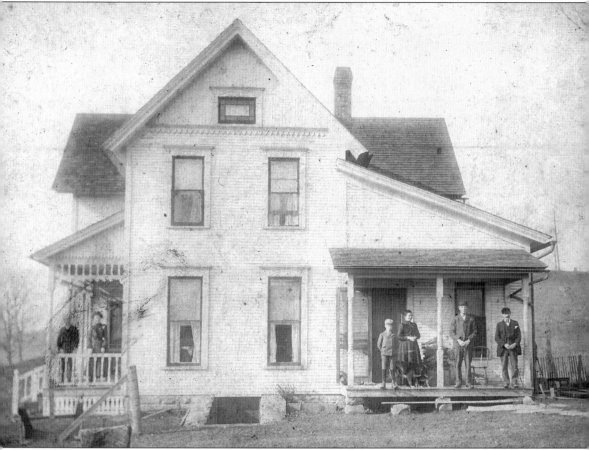

Born in 1857, Lanson Barker lived his entire life in Bath Township. He married Alice Behmer and they had three children. About 1883 he built this house on Yellow Creek Road on land he inherited from his father.

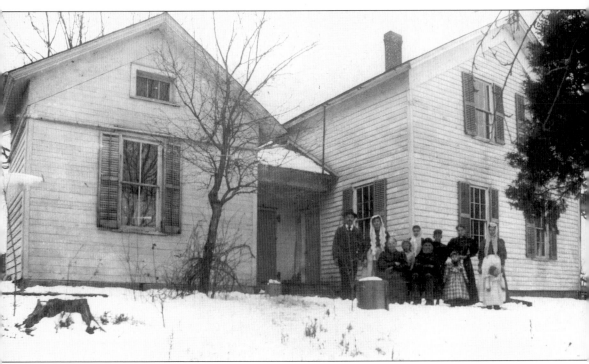

The main part of this house on Oak Hill Road was built by Edward Cranz in 1867. The addition to the left was built in 1890. A note on the back of the photograph identifies the people from left to right as: (front row) Louise Staehle Cranz, Edward Cranz Sr. (both seated), Eunice Cranz Grogan, and Celia Cranz; (back row) the last two women on the right are Mary Cranz and Caroline Dresher Cranz. The photo was taken in 1894.

Eugene and Nettie Cranz took over the Hammond-Cranz house and farm in 1906. Cranz was raised in this house, and he and his wife raised their six children in it. They remodeled it and changed the front porch. Many of the acres on the land were dedicated to tree farming.

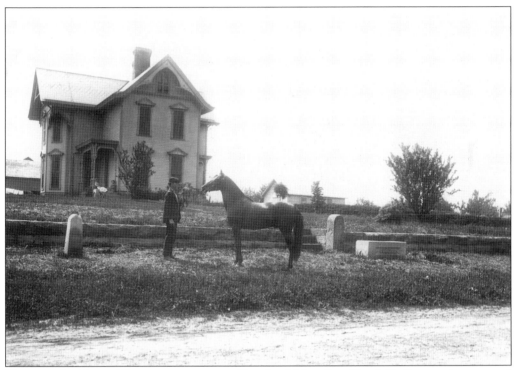

This was the Davis 15-room mansion on Cleveland-Massillon Road. Built sometime around 1873, it had four fireplaces faced with Italian marble. The woodwork was walnut, butternut, oak, and cherry. A windmill pumped water into a second-story reservoir that provided running water for the kitchen and bathroom. In the 1950s Raymond Firestone bought the 500-acre farm. The man in front of the house was George Davis.

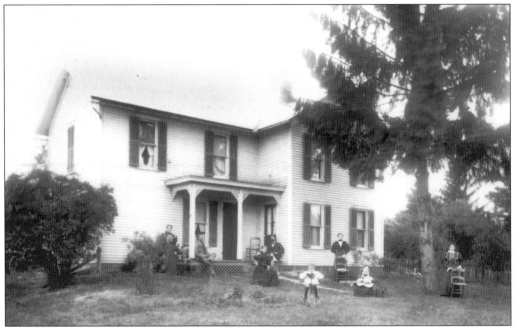

In 1885 Charlie Heller built this large farmhouse on 150 acres of land he bought from Mr. Hershey. At one point the Louis Linder family were farm tenants there. In 1913 Willis Thornton, founder of the *Akron Times Press*, bought the land for $12,000. He and his wife named it Wellworth Farm, because they thought it was well worth the money. The Thornton's did not live on the farm, but took interest in its operation. They hired Ed Robinson as a farm tenant, who helped to build up the dairy herd. When he died in 1925, the Thornton's hired Clarence Plank who had graduated from Ohio State's college of agriculture.

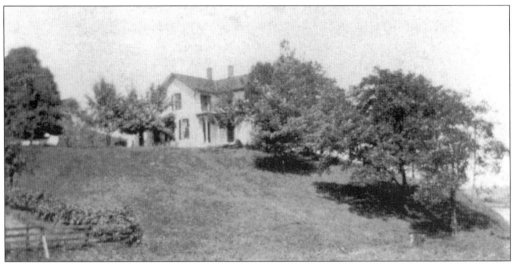

In 1907 James S. Hine, a professor of entomology at Ohio State University, bought this house and surrounding apple farm at Ira. He, his wife, Abbie Parker Hine, and their four children spent their summer vacations here. Third son, Gaylord, and his wife, Ethel, lived and raised their family in the house. It was built in 1874. (*Photo Courtesy of the Peninsula Library and Historical Society, Peninsula, Ohio.*)

This photo shows how Wellworth Farm looked while Clarence and Eulalia Plank lived in the house and worked the farm. There were three porches, an attic, and 11 rooms with high ceilings and dark oak woodwork. A coal range and kerosene stove were used for cooking. The Planks lived in the house for 32 years. The land was eventually sold to developer Don Brown who subdivided it into 86 lots and called it Meadow Park.

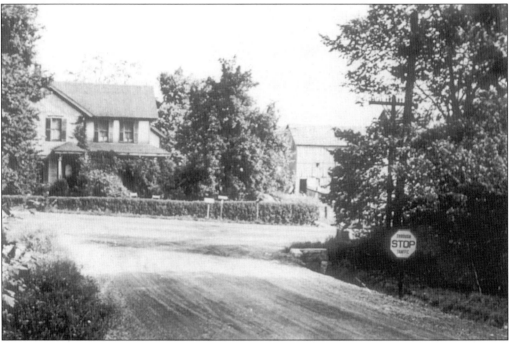

The Fryman's family homestead was built about 1878 by George and Laura McMillan. William Fryman purchased the farm in 1884 and raised horses and cows.

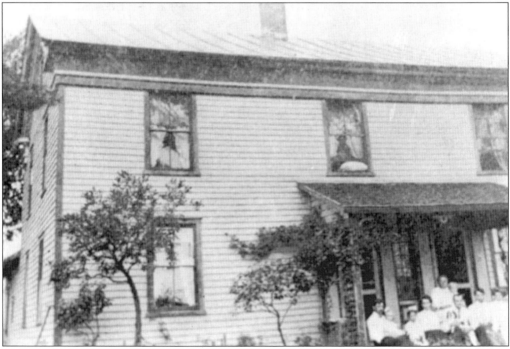

Charles Joss, a relative of the Cranz family, came to Bath in 1894. He and his family lived in this house on Ira Road. He owned a cheese factory, also on Ira Road, in the valley. Pictured here are Lynn and Erma Joss Miller and family.

This photograph is simply identified as Sara Hersy (Hershey?) Miller's home. It stood at the north end of Wye Road in Ghent. In more recent times, it became Robert Renner Interiors.

This photo is identified as Lon Alexander's home.

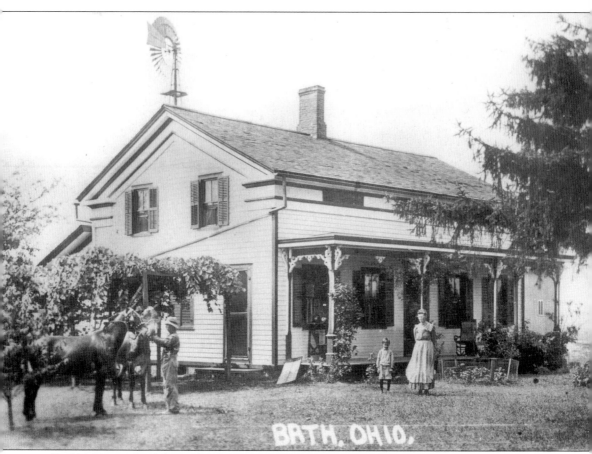

Earl McKisson (with horses), Clarence Brock (little boy), and Mary Miller are pictured in front of the Will Miller house.

Kate Cranz built this house on the western rim of the Cuyahoga Valley after she retired as head of the department of modern languages from Ohio University. The Swiss chalet-style house was inspired by her travels abroad. Neither she nor her sister Cornelia ever married. They lived together in this house until it burned in 1923.

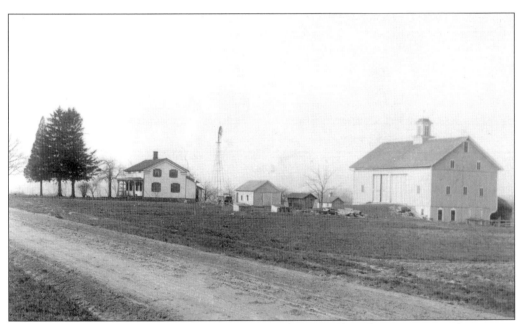

This photo was taken of William F. and Mary Goodman Miller's farm on Ira Road sometime before the road was paved in 1916.

Harry and Marcia Miller Brock lived in this house. Marcia died of typhoid fever in 1906, leaving her only son, Clarence, to be raised by his grandparents. The woman in the picture is unidentified, and there is no date given for the house.

Roy and Maude Miller McKisson were married in 1908, and this was their home for decades. The lumber for this house on Cleveland-Massillon Road came from the original Bath Town Hall. Roy was a carpenter and built numerous houses in Bath. Maude stayed in the house until she was into her 90s.

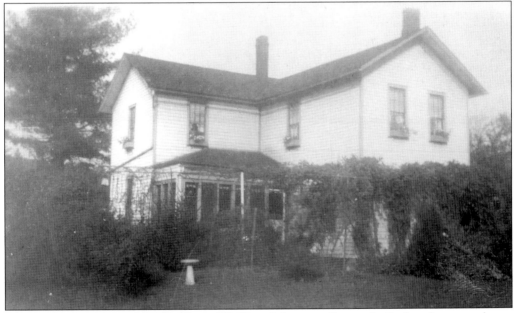

No date is given as to when the Henry W. Howe's house at Ira was built, but there are photos of it back as far as 1907. It was home to Edwin and Abbey Howe Sheppard for many years. Fire destroyed it at 3 a.m. on July 13, 1944.

Lewis Cranz built this house on Oak Hill Road in 1910 after moving from Akron back to Ira where he was to supervise farming operations for C.O. Hale. He sold the house in the 1920s to Arthur McNeil. Hale Farm and Village Museum bought it in the 1960s and demolished it.

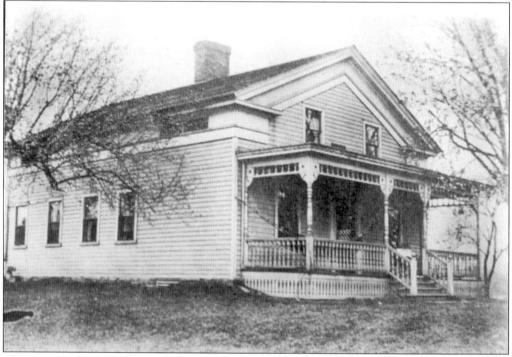

This was the Armitage home on Ira Road.

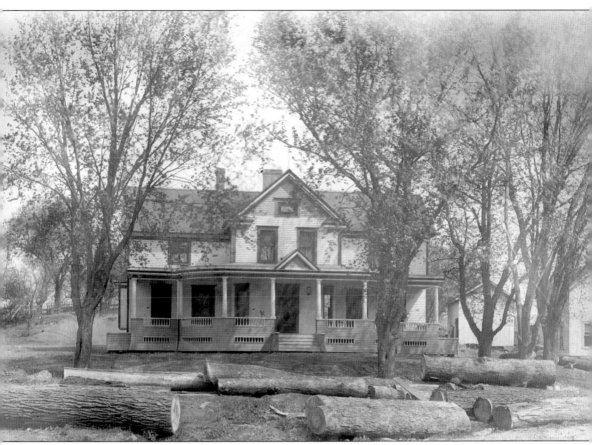

Roswell Hopkins built this house with its decorative millwork on Granger Road in 1910. The home was state of the art for that time with hardwood flooring, four bedrooms on the second floor, a third floor attic, and a special room that would later have indoor plumbing. A small organ sat in the upstairs hall, and one of the four Hopkins girls would play it to cover noises when anyone used the slop jar. Descendants still remember Christmas Eve in the house with all the cousins and marvelous food. The house has been restored.

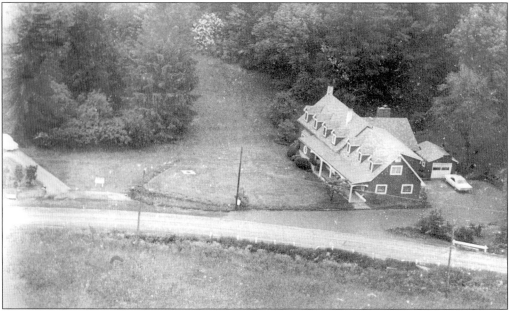

William and Jean Falor bought this "house of seven gables" in 1952. It was originally a barn that had been added onto and converted into a summerhouse before 1940. It sits on Ira Road adjacent to Hale Farm and Village Museum.

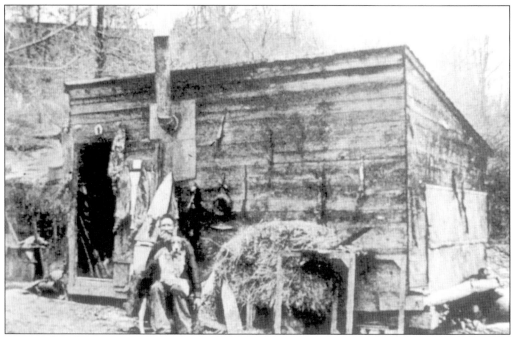

Dirty and unshaven, "Nelt" Mills was called the "Mayor of Ghent" or the "Hermit." Although he dug wells and laid drainage pipe, his favorite pursuits were hunting and trapping. A story circulated about him getting drunk and killing a man during an argument. He lived in this hillside cabin just north of Ghent on the curve of the road. The hut was torn down when the curve was altered and the hill was cut back.

Three
MILLS AND PROSPERITY

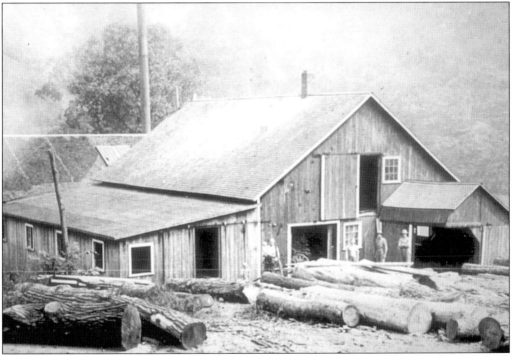

The Hopkins Lumber Mill was the first sawmill and power sawmill on Yellow Creek. It was built by James Root during the early 1820s and was operated from 1825 to 1831 by Seth Turner. Isaac Hopkins took over the mill in 1831. It stayed in the Hopkins family for four generations until 1953. The timber came from local farms and was turned into a variety of lumber, as well as door frames, windows, porches, bric-a-brac, and picket fence posts made with a machine they bought from a neighboring mill in 1905. The mill used a ten-foot vertical whipsaw, which took a half-hour to cut through one board. In 1846, the mill changed its power from an undershot wheel to a flutter wheel. An overshot wheel was installed in 1890 and used until 1903 when a water turbine replaced it. That same year, a second turbine with a 14-inch gate was also installed.

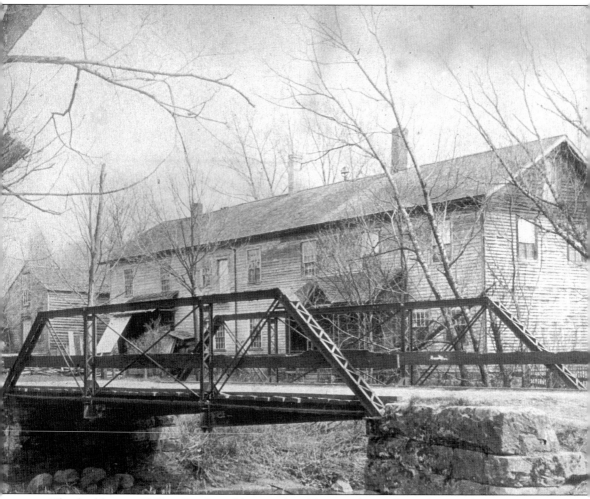

This building on Yellow Creek in Ghent is the oldest woolen mill in Ohio. Built in 1832 of oak timber by Allen and Bloom, the mill still stands on its hand-cut sandstone foundation. The original windows, made from hand-rolled glass, are still intact. The mill changed owners several times. Alonzo Coffin ran the mill from 1860 to 1875. Coffin is credited with turning 10,000 pounds of fleece a year into cloth, woolen blankets, yarns, flannels, satinets, "cassimeres," and coverlets. The fleece came from all over northeastern Ohio. A crane lifted the fleece from the wagons to the upstairs. The next owner, Henry Pardee, manufactured waterproofed fabrics. The "Hammerstain process" made the fabrics waterproofed on both sides and resistant to heat and cold. Pardee sold the mill to Chester Purdy who converted it to a machine shop. In 1892 Mr. and Mrs. Henry C. Freeman turned it into apartments. The building has passed down through five Freeman generations. It is still lived in today and has an Ohio Bicentennial Commission Historical Marker.

Warehouses were part of the woolen mill on Yellow Creek in Ghent.

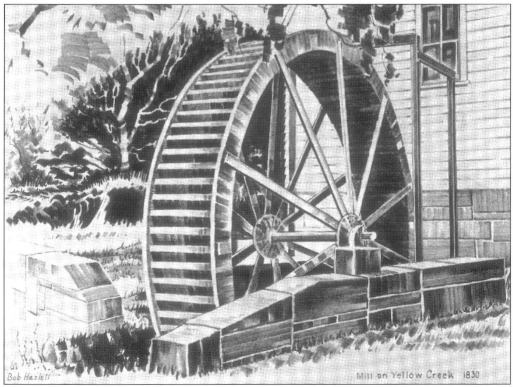

Bob Hazlett

Mill on Yellow Creek 1830

This drawing by Bob Hazlett shows what the water wheel might have looked like at Yellow Creek Mill in 1830.

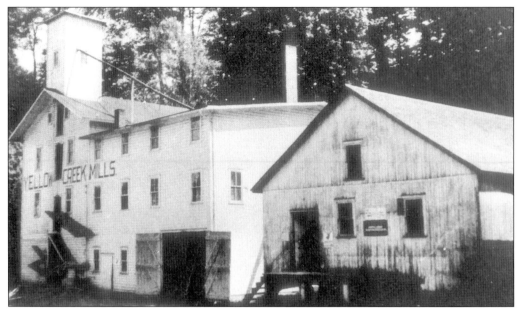

John Miller originally built Yellow Creek Mill about 1830 as a gristmill. The millstones were made of French flint stone, brought to the United States as the ballast for a sailing ship. The stones were re-cut to lock together, then held by a steel hoop. The mill changed hands several times, including a land trade when Edward Heller traded it to Abe Hershey for a farm. A number of improvements were made through the years. Hershey built a water wheel and a large addition to the building. His son-in-law Frank Rothrock added a steam engine. Around 1913 a steel turbine was installed. It was later supplemented with a gasoline engine. Fire leveled this historic mill and its two warehouses on a minus 20-degree March morning in 1943. The loss was estimated at $20,000. R.W. Mills of Lorain was the owner.

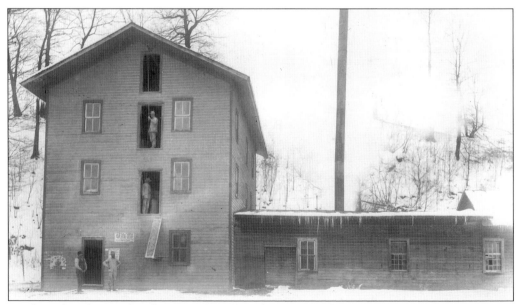

Frank Rothrock owned Yellow Creek Mill at this stage. When Yellow Creek was too low to produce power one summer, he added a steam engine.

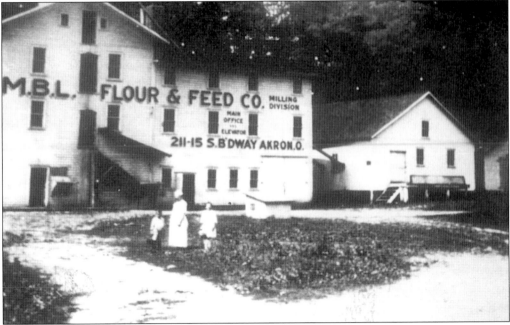

In 1918 Roswell Hopkins bought the Yellow Creek Mill. He sold it a year later to Mills, Brown and Laubach Company.

After the 1943 fire destroyed the Yellow Creek Mill, Sterling Alderfer purchased the site and rebuilt the mill. Later, the building was turned into a manufacturing plant that ran on electricity generated by the waterwheel. Monarch Rubber owned it for a period and manufactured polyurethane. This building still stands near the bridge over Yellow Creek Road.

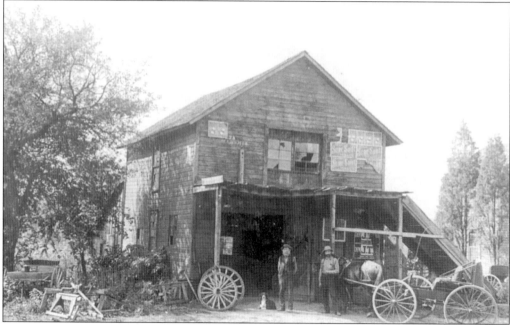

In the early 1900s, Joseph Bailer's Buggy Shop on Ira Road faced the Bath Congregational Church.

Eight-foot straddle wheels, invented by Jared Barker and built by Joseph Bailer, were used to haul large loads of logs to the mills. Two teams of horses or oxen were needed to pull the burden.

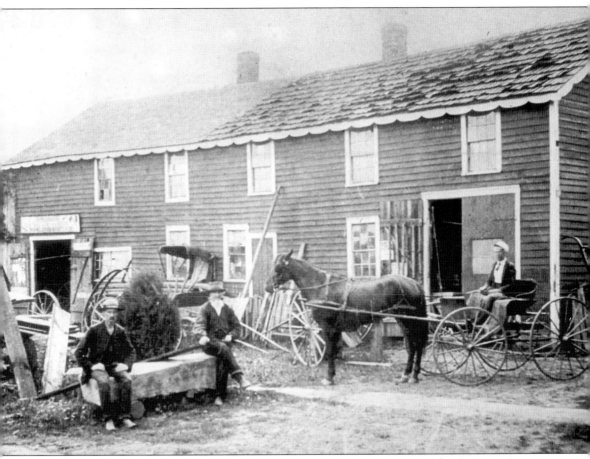

Cleman Noah Jagger built the Jagger Buggy Shop in 1860 at Hammond's Corners. Jagger learned his trade as a fancy surrey and wheel maker in nearby Boston Township. Inside, the buggy shop had heavy oak benches, a hand-operated flywheel drill press and a forging area to heat and wrought iron parts. A large bellows suspended from the ceiling forced air into the forge. The second floor featured a windlass that lifted the carriages up and down between the floors on two long planks. One corner of the second floor was set aside as the paint shop. The paint was mixed in a round mixer, which was turned by hand. The lathe and plaster were multicolored from the men cleaning their brushes on the walls. Jagger was well respected in Bath Township and surrounding communities.

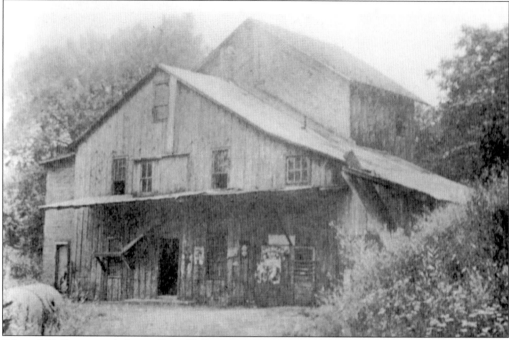

Edward Heller owned this mill on Yellow Creek Road east of Ghent. Sometimes called Quinn Heller's mill, its main power source came from a millrace that started where Cleveland-Massillon Road crossed Yellow Creek. The water was stored in Hershey's Pond. Heller bought the mill from Lanson and Jared Barker in 1871 and operated it with his sons, Benjamin and Quintas, until he sold it to Henry Pardee. Pardee sold it to Otto and George Hershey in 1895. It was destroyed by fire in 1917.

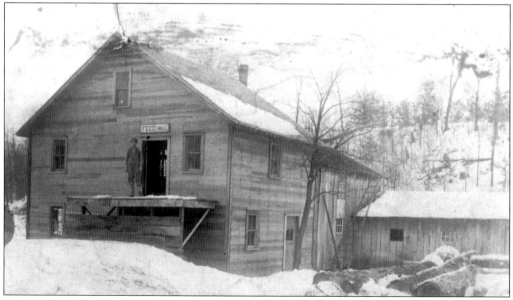

Established about 1900, Snyder's Mill was a feed mill that was run by a steam engine. It was located just north of Ghent on Cleveland-Massillon Road.

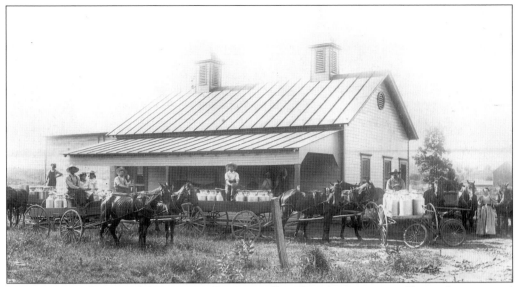

Farmers made cheese and butter out of excess milk rather than waste it. Cheese factories and creameries were built to handle the processing. Jason Sumner built this creamery on Medina County and Granger Roads in 1902, although the picture is dated 1898. The business flourished and in 1918 Sumner moved the creamery into Akron. His nephew, Ray Sumner, and his wife Bertha ran the creamery for a short period. In 1930 a tornado all but destroyed the building leaving the churn and cement floor. Later, the old churn was swept away in a flash flood.

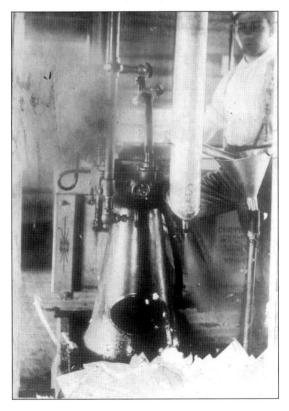

This is a view of a worker inside the Sumner Creamery. The picture is dated 1898.

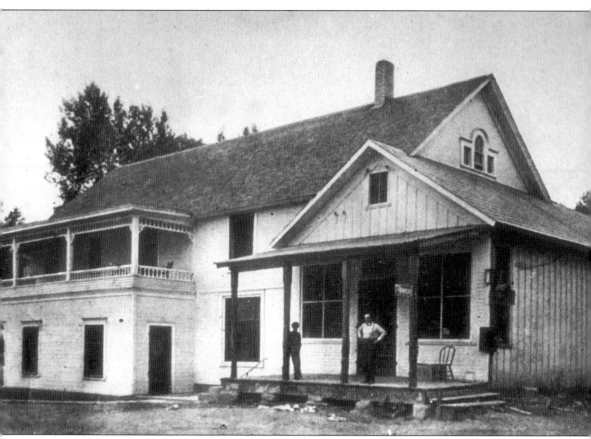

Delbert Statts' general store stood on the corner of Granger and Wye Roads in Ghent. The two-story store was operated during and after the Civil War by Henry Pardee. At the time his son Gene sold it to O.R. Hershey, it was the only building with a telephone. Hershey sold the store to Statts around 1918. On Friday, August 1, 1955, fire destroyed the store, warehouse, and the Statts' home.

Built before the Civil War, Statts' general store was a popular gathering place for men of all ages until it burned in 1955.

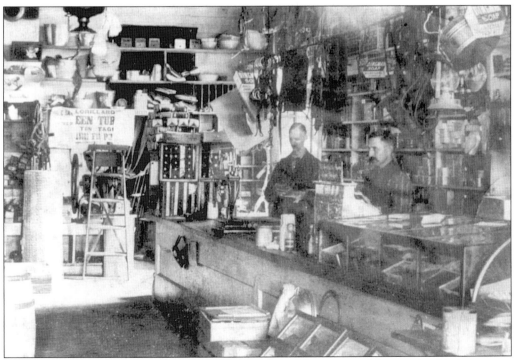

This interior photo of Statts' gives the reader an idea of the extent of the store's wide inventory. The store carried everything from axle grease to shotgun shells.

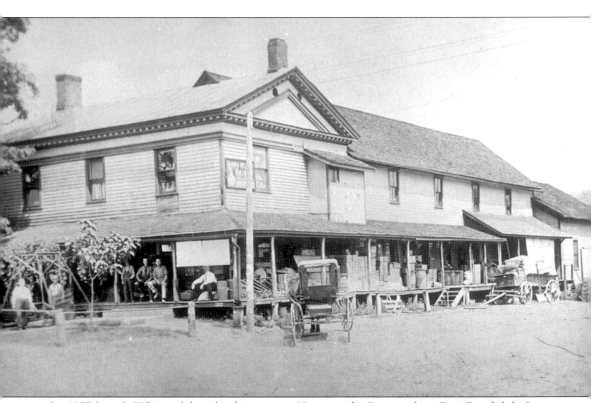

In 1877 Joseph Whitcraft bought this store at Hammond's Corners from Reis Randolph. It was built sometime during the mid 1800s on the northeast corner of Cleveland-Massillon and Ira Roads. When Whitcraft died in 1888, the store passed to his son Sigel B. Whitcraft. Whitcraft's Store became the second largest general store in Ohio. Customers came from surrounding counties to buy everything from wallpaper to a 300-pound wheel of New York cheddar cheese. Credit was a large part of the business, and local farmers often brought their livestock or produce to trade for supplies. The building and $65,000 worth of stock went up in flames in January 1912.

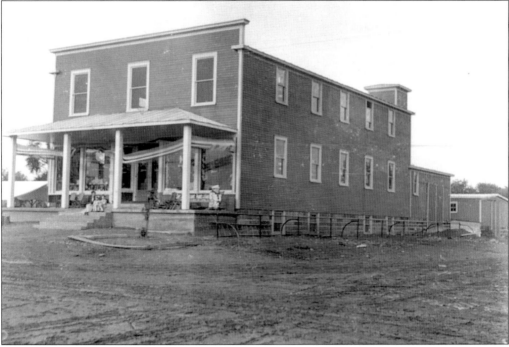

Whitcraft's was rebuilt in 1912, the same year the original building burned. Neighbors helped local carpenters rebuild the store with mostly oak lumber from the Hopkins Mill. Dirt roads, Cleveland-Massillon and Ira, ran in front and along the side of the store. The building now houses the Garth Andrew Company.

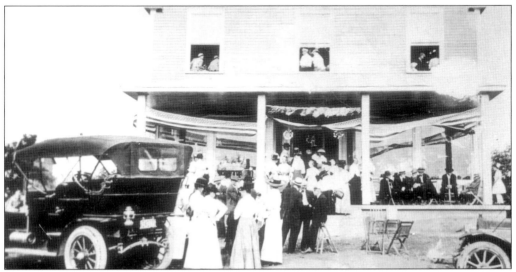

A gala grand reopening of Whitcraft's Store in the summer of 1913 drew crowds to Hammond's Corners. The new store had a soda fountain near the front entrance and a dance floor on the second floor. On Saturday nights the dance floor was crowded and the soda fountain did a brisk business.

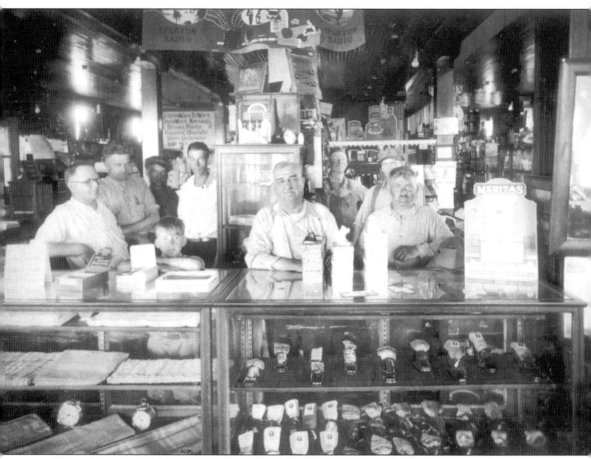

This photo shows the interior of Whitcraft's Store about 1925. Standing against the counter (front row) from left to right is: Ralph Andrew, Garth Andrew, Sigel B. Whitcraft (owner), and George Nemer. In the background from left to right are Ray VanDevere, George Davis, Jay Davis Jr., Jay Davis, and Ed Pickle.

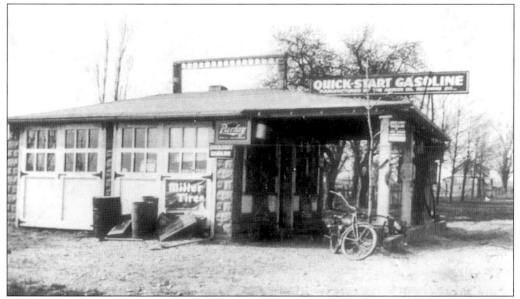

Saxe's Market, on Cleveland-Massillon Road at Hammond's Corners, was probably built around 1900. Owned by Solomon Saxe, the store changed over the years until it was torn down to make way for the post office. This view shows it as a garage and grocery. The gas pumps were gravity flow glass tanks. Inside the store, customers had their meat cut, picked bananas hanging by the stalk, and slid pennies and nickels into the slot machines. The store had a reputation for having the best ice cream cones in town. (*Photo Courtesy of the Peninsula Library and Historical Society, Peninsula, Ohio.*)

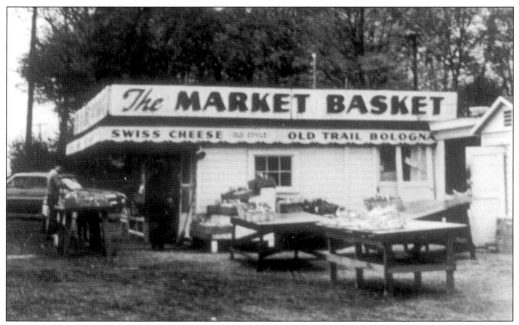

The Market Basket opened in 1954 at the corner of Shade and Cleveland-Massillon Roads. Owned by Ivan and Atlanta Mishler, it was popular place for Bath residents to pick up fresh vegetables and fruit, as well as milk, eggs, etc. It closed in 1965.

59

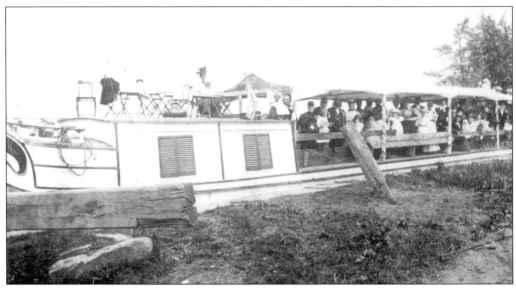

On July 4, 1827, a 39-mile stretch of the Ohio and Erie Canal opened between Cleveland and Akron. Part of it ran across the northern border of Bath. It had a huge economic impact on the whole region. It not only brought new families but businesses that saw it as a way to ship their goods as far away as New Orleans. Pictured is a packet boat, or passenger boat, as it passed through one of the locks.

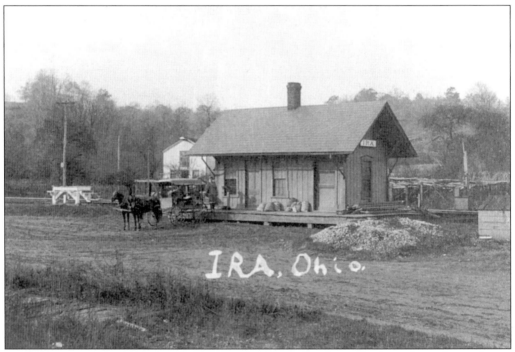

One of the first train stations built along the Valley Railroad was Hawkins. It was located near a bridge built over the canal by Ira Hawkins. When it was learned that another station in Ohio had the name Haskins, the station in the valley was renamed Ira. (*Photo courtesy of the Peninsula Library and Historical Society, Peninsula, Ohio.*)

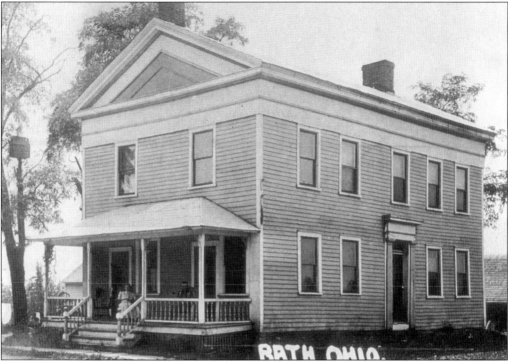

The Landmark Inn (1860–1945) stood on Cleveland-Massillon Road at Hammond's Corners. It was a stagecoach stop and hotel for travelers on their way to Cleveland from Massillon.

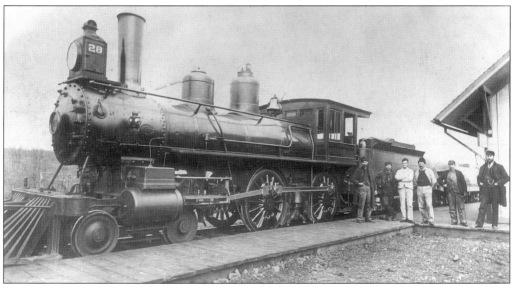

The first train rolled into Hawkins Station at Ira on January 28, 1880. The Cleveland, Terminal & Valley line that ran from Cleveland to Canton stopped at three valley locations including Botzum, Everett, and Hawkins. The Baltimore & Ohio Railroad bought the CTV in 1906. The railroad gave Bath wide access to travel and trade.

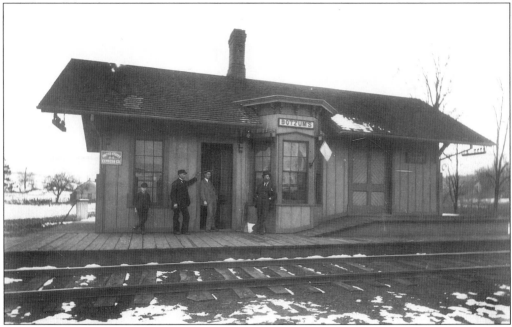

Botzum Station was a short distance down the Valley rail line from Ira Station. Lynn Worden was the station agent.

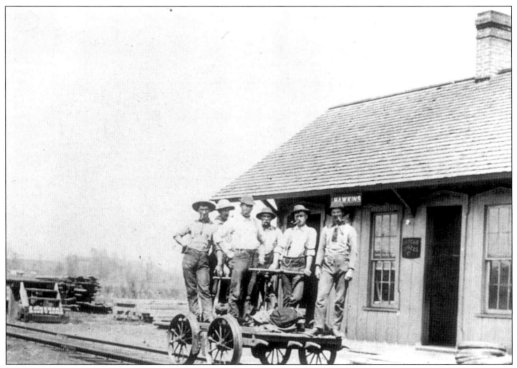

A railroad gang in front of Hawkins Station.

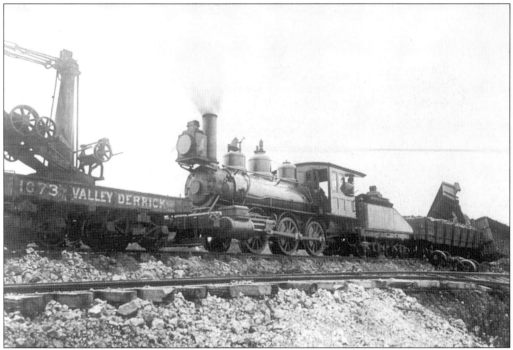

The Flood of 1913 caused washouts along the Valley Railway and stopped rail service for more than two weeks while crews hastily repaired the tracks. This train at Botzum was one of the casualties.

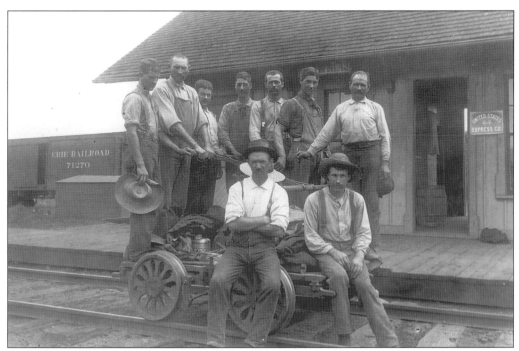

A section gang poses for the camera on a handcar in front of Hawkins Station.

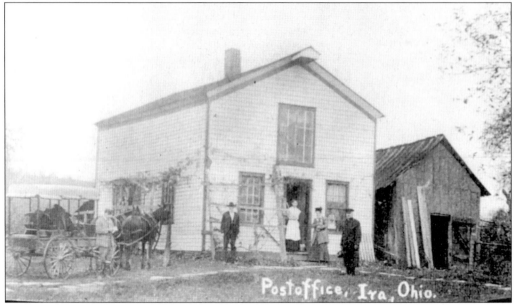

In 1883 Henry W. Howe asked the government to establish a post office at Ira. It was located on the trackside of Ira Road. When he retired as the first postmaster in 1906, his daughter Abby became the postmistress, a position she held until 1940 when the post office closed. In this picture Abby is in the doorway of the post office. Henry is on her right. The wagon belongs to C.O. Hale.

The Ira post office once housed Howe's Printing Press. This is a salesman visiting the printing press.

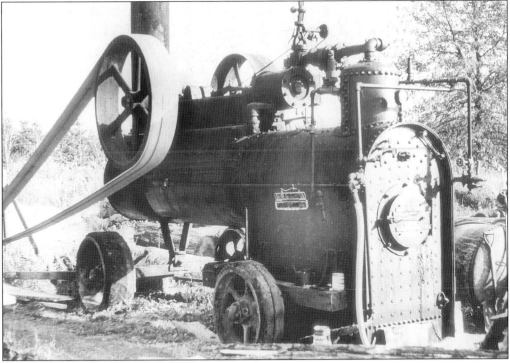

This is a steam engine used by farmers as a power take-off for threshing. Similar steam engines were used at the sawmills. Luman Cranz probably owned this one. Fascinated by steam engines, he loaded his Baker engine onto a lowboy and traveled across the state to engine shows during the 1920s through the 1930s.

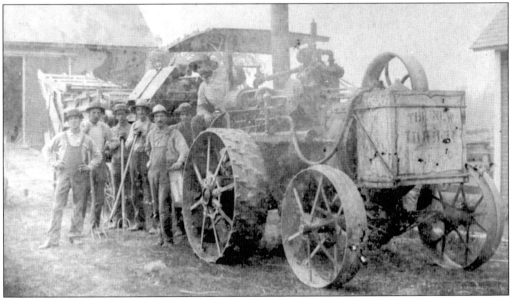

Will Robinson's threshing machine was at Clair Smith's farm when this photograph was taken. During the 1930s a ten-year-old Ivan Ganyard remembered the visits of the threshing machines from farm to farm and the dirt on the faces of the men.

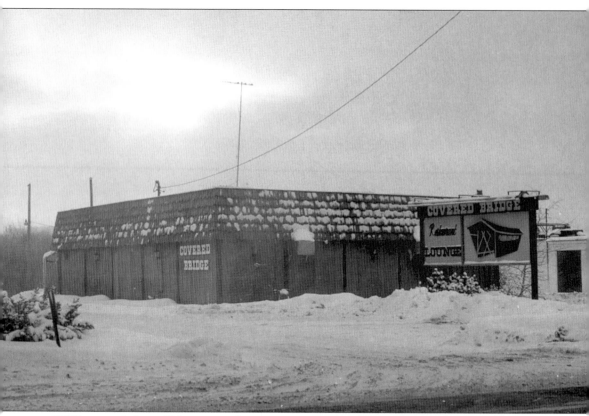

William and Jean Falor opened an ice-cream stand on Cleveland-Massillon Road at Hammond's Corners in the mid 1950s. In the 1960s, the owners closed in the ice-cream stand to make it a sit-down restaurant called the Other Place. After another remodeling in the late 1960s, they reopened the restaurant, this time calling it the Covered Bridge Lounge. A bar had been added, as was an upright piano. The "Bridge" became very popular with Bath residents for its good food, sing-a-longs, and camaraderie.

Four

SCHOOLS AND
CHURCHES

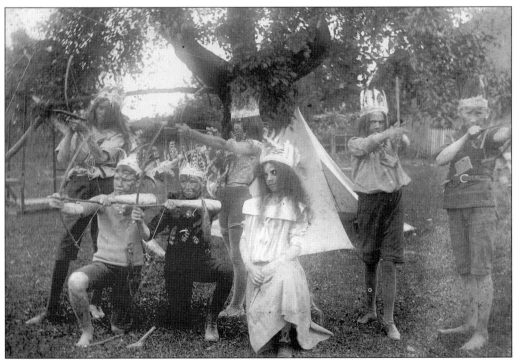

This group of children was dressed in costume for an Ira School play about 1911. Glenn Howe
Sr. is the second, kneeling boy.

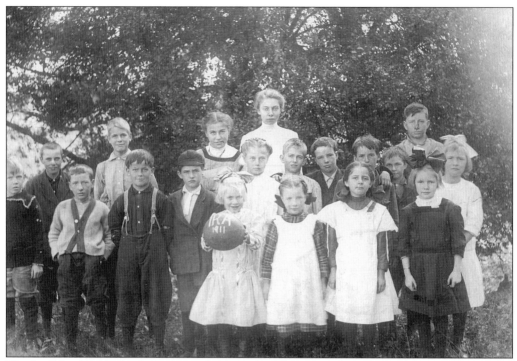

The Ira School students of 1911 were: first row, third from the left Earva Bender; second row, third from the right, Frank Bender; and back center, (left) Doris Cranz and (right) Ceilia Cranz, teacher.

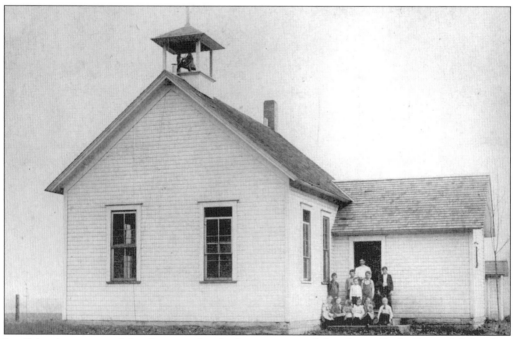

Ira School was one of the district schools that was consolidated into Bath Central School in 1923. The 11 one-room schoolhouses were auctioned off in August 1923. The Ira School was sold for $270 to E.A. Porch and remodeled into a house.

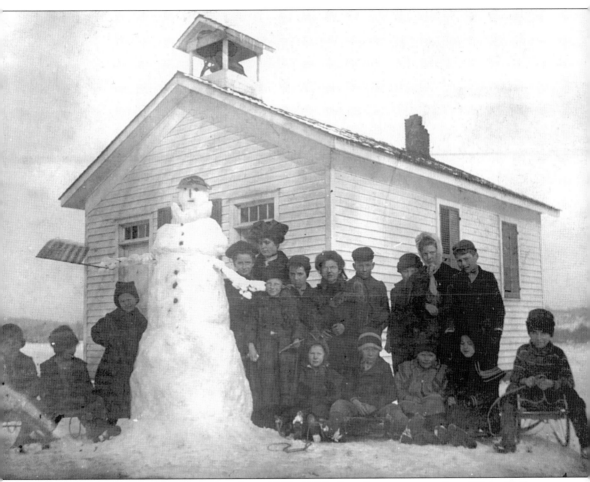

This was the first schoolhouse in Ira about 1903–1904. As a beginning teacher, Claira Bailer (back, middle) earned $30 a month during the 1902–1903 school year. The students, from left to right, are: (first row) Fred Alby, Earl Martin, Glenn Howe, unidentified, Clara Alby, Garcia Cranz, (?) Cranz, Doris Cranz, Katy Walters, and Luman Cranz; (back row) Claira Bailer, unidentified, unidentified, Herbert (?), Ray (?), unidentified, and Ralph (?).

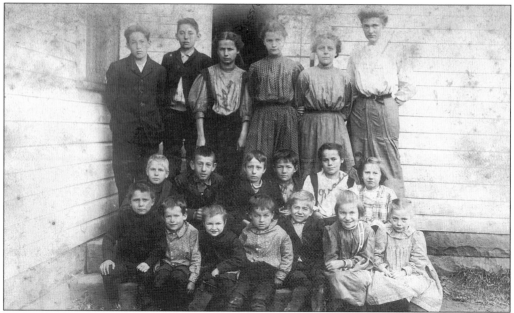

This was the Ira School student body about 1907–1908. In the first row, second and fourth from the left are Frank Bender and Earva Bender. In the second row, fourth and fifth from the left are Lloyd (?) and Grace Bender. In the back row, first and third from the left are Harry Bender and Bessie Bender.

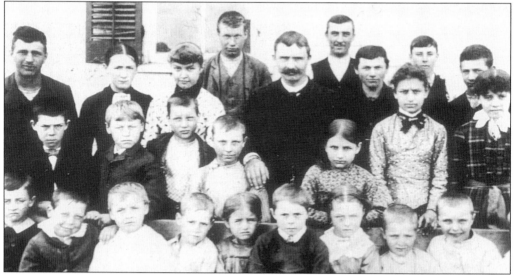

McAllister school children posed for this photograph taken in 1886. They were from left to right: (front row) Frank Vallen, Willis Bolinger, Fred Myers, Clyde Vaughn, Daisy Fryman, Lydia Cook, Bertha McAllister, Sherman Boltz, Sherdon Boltz, and Ira Myers; (second row) Harry Bolinger, Will Myers, Arthur Hutchison, Albert Boltz, Sade (Sadie?) Fryman, Elmira (Arminta?) Fryman, and Nettie Vallen; (third row) Alex Fryman, Edith (Sadie?) Heintz, Lydia Myers, Warren Hutchison, teacher Bert Showers, Charles Boltz, unidentified, Ed Bause, and unidentified. A note with this picture reads, "Jack Fryman unaccounted for—possibly one of the above."

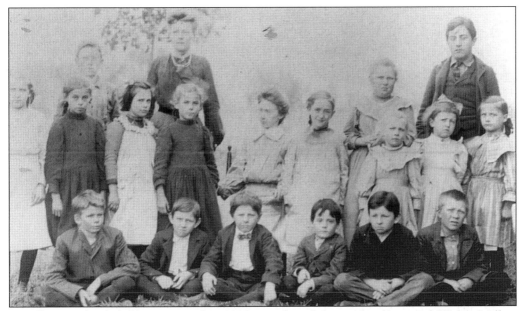

McAllister School children pictured in 1903 were from left to right: (first row) Walter Miller, (?) Morris, (?) Taylor, Paul Bergdorf, Albert Morris, and Billy Lueck; (second row) Augusta Jordon, Julia Sourek, Mable Beck, Helen Sourek, May Burroughs, teacher, Nona Miller, Mary Lueck, Margaret Norris, and Gladys Taylor; (third row) John Morris, Mabel Beck, Elsie Lueck, and Henry Bergdorf. The children drank water from a pail with a community cup and used the outhouse behind the school building.

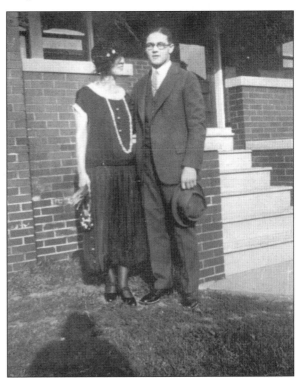

Helen and Ford Crile were on their honeymoon in Detroit in 1924 when this photo was taken. They courted during 1922 and 1923 while Helen was a teacher at McAllister School. She lived in her home in Ghent on weekends, but boarded at the McAllister home closer to her job during the week. All eight grades attended the school, and some of the older boys were hard to handle. Ford went to school with her each morning to get the fire going and get the boys to settle down. Helen Hopkins Crile died at 102.

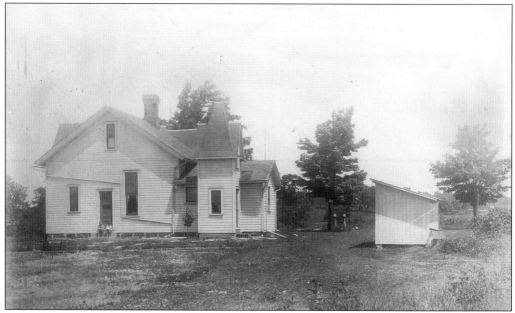

This is believed to be the East Bath schoolhouse built in 1880 by Perry H. Alexander. It was sometimes referred to as Little Germany school because of the many German immigrants who settled in the area. The school closed and was put on the auction block in 1923 when the school districts consolidated. Today, the building is a private home.

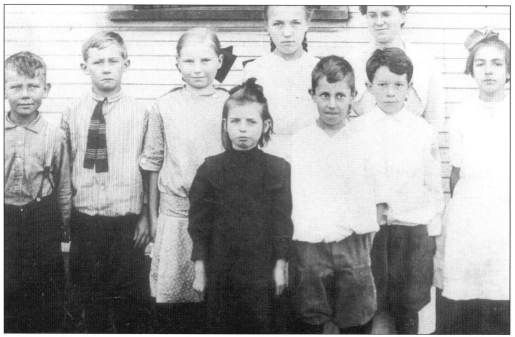

Hammond's Corners School children posed for their picture in the spring of 1914. They were, from left to right: (front row) Dorothy Boughton, Clarence Brock, Jay Davis Jr., and Elzora Osborn; (second row) Andrew Evers, Harold Rininger, Ruth Alexander, Mary Osborn, and Ethel Andrew, teacher.

72

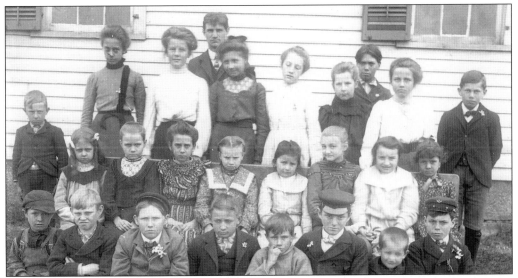

Hurd's Corner at Bath and Hametown Roads had a school by 1828. The teacher, who also served as janitor, principal, and woodcutter, taught eight grades in this one-room school. In 1890 Hurd's Corner was the most heavily populated area of Bath. The school was dismantled in 1926 and used to make an addition to a private home. Some of the children are pictured here. There is no date on this photo and only one person is identified. Grace Low (Black) is in the fifth person from the left in the third row.

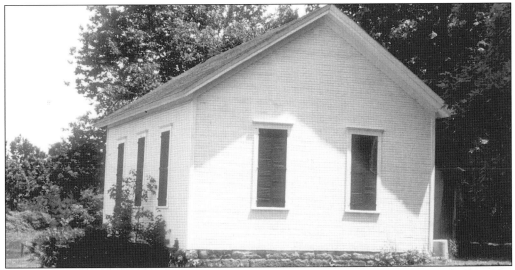

The Stony Hill School was built in 1892 on an acre of land deeded from Laura McMillan. Her only stipulation was that the land would revert back to her or her heirs upon the school abandoning the property. When the district schools closed in 1923, Alex Fryman purchased Stony Hill School building for $175. Since Fryman was a grand nephew of Mrs. McMillan, the land was transferred to him for $1. During the 1940s three different families, including the Fryman's, lived in the school building. A beekeeper also took up residence for a time. Later, Fryman's son-in-law Eddie Stein used the old school as a tool shed. Finally, in 1980 Stein and his wife, Alleen Fryman Stein, deeded the schoolhouse, which is off Hametown Road, to the Bath Township Historical Society. The building has been restored and still stands today.

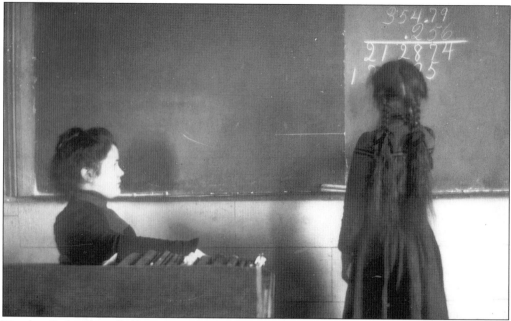

Teacher Sadie Shaw (left) is pictured with an unidentified student at the blackboard of Farley's Corners school.

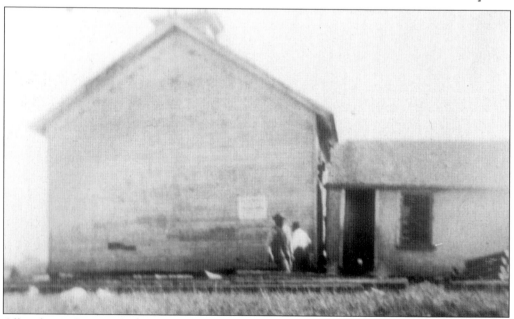

All eight grades were housed in Farley's Corners one-room school at W. Bath and N. Medina Line Roads. A pot-bellied stove in the center of the room warmed the school in winter. The children decorated the boys' and girls' outhouses with bright-colored wallpaper and pictures and padded the seats with newspaper. One of the teachers, Buell Emerson Crum, was remembered for "keeping discipline" with a rubber hose and a split bat. Another teacher, John E. Roberts, told students it was state law to read a chapter from the bible in class each day. This photo was taken in 1923, shortly before the school closed. The building was later used as a chicken coop.

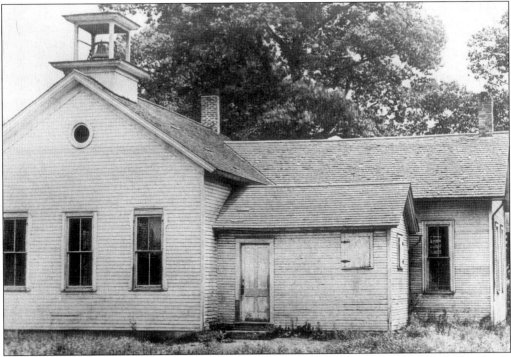

Ghent School was built before 1900 on the southeast corner of Yellow Creek and Cleveland-Massillon Roads. It was the largest school in Bath Township at the time with two rooms and two teachers. When the building was taken down, it was divided into two altered structures, which were then included into two different homes.

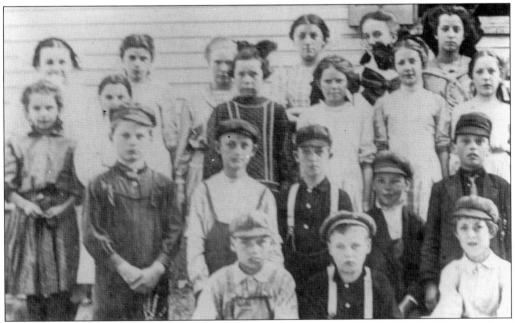

Fifth, sixth, seventh, and eighth graders from Ghent School posed for a picture about 1910–1911. Mary Astin was the teacher.

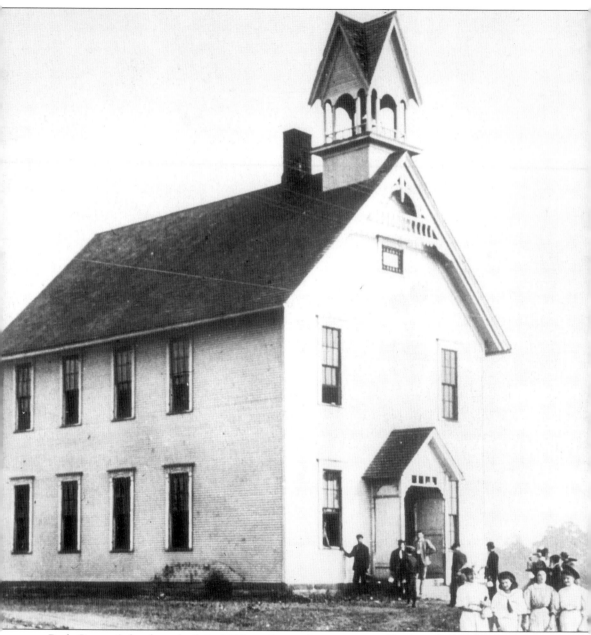

Bath Center School was built in 1893 on the southeast corner of Bath and Cleveland-Massillon Roads. The second floor was used for the high school and half of the first floor was used for elementary grades. Clyde Berry was the principal. High school students paid $40 year tuition. Elementary school was free. Five students in the class of 1895 were the first to graduate from the high school. However, it wasn't until 1909 that the school gained accreditation so students could enter college. The school was called the "Temple on the Hill." The construction was so poor, it swayed in heavy winds. It was taken down in 1923, and its materials were used to build a home on Ira Road. Pictured at the window are George Bigelow and Alba Barker. On the step is the teacher, (?) Kent. The girls in the lower right are left to right: Nellie Galloway, Ester Worden, unidentified, and Ethel Smith.

76

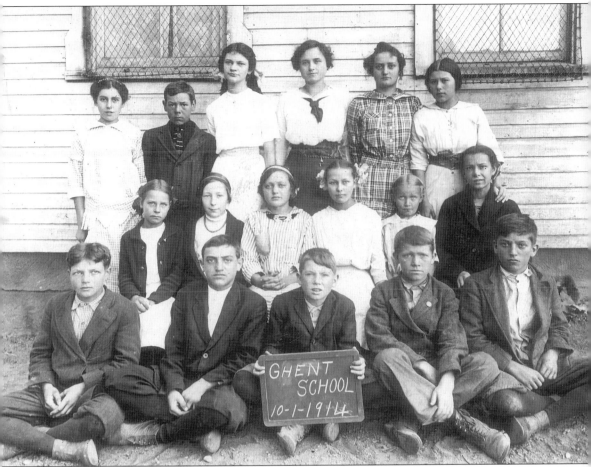

In 1914 Ghent school children posed for this photograph. The children are listed on the back of the photo from left to right: (front row) Ford Crile, George (?), Bob Alexander, K. Bailey, and A. Robinson; (second row) Nita Hopkins, Marie Miles, Ossa Ingersoll, Esther Fasnocht, Violet Bailey, and Mary Freeman; (third row) Anna McFarlin, Paul Hopkins, Mary Oviatt, Nellie Heller, teacher, Sybil Ingersoll, and Florence Hodgeman.

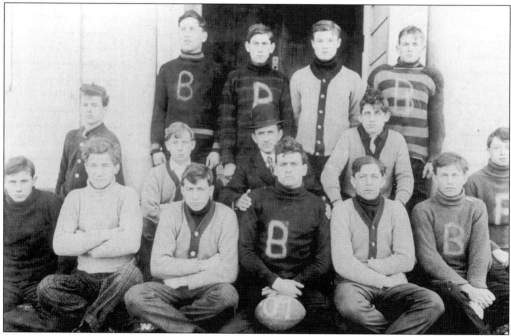

Bath High School 1909 football team was from left to right: (first row) Wayne Robinson, Alba Barker, Clare Baxter, George Bigelow, Park Smith, and Perry Shaw; (second row) Tracy Freeman, Harvey Miller, Chester G. Wise, coach and school principal, Arlo (James) Miller, and Russell Bair; (third row) Gilbert Edgar, Ray Smith, McKinley Pierson, and Lee Shade.

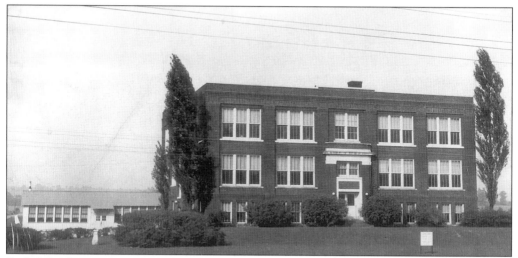

Bath School opened in September 1923 on the corner of Cleveland-Massillon and Bath Roads. The total cost to build and equip this new school was $112,000. Roy Pugh was the principal. By 1929 enrollment had increased, so the school board purchased a portable building (at left). In 1930 gas in the coal bin in the furnace room exploded. One student died and four others were injured. Damage to the structure was reported at $14,000. One of the trees at the left of the building was planted in memory of the student that died. Bath became a grammar school in 1952 when Revere High School opened. Two more wings were added onto the school during the 1960s.

Roy Pugh worked his way through school at Ohio Northern University by playing the piano for silent movies. After serving in World War I, he came to Bath Township to teach. In 1920 Pugh was named the principal of Bath High School, which had 45 students. He continued to teach after becoming the principal.

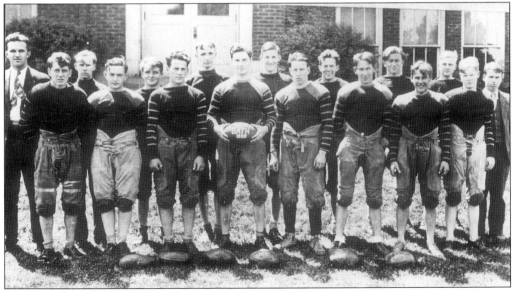

The 1929 Bath High School football team wore protective gear.

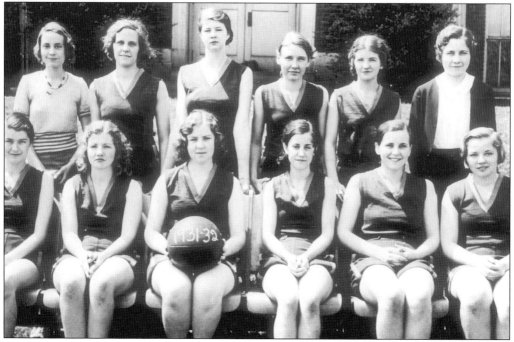

The 1931–1932 Bath High School girls' basketball team is shown here.

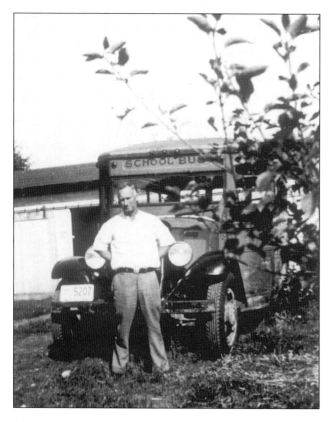

Bus driver Earl Horn poses with an old Bath High School bus. The photo is undated.

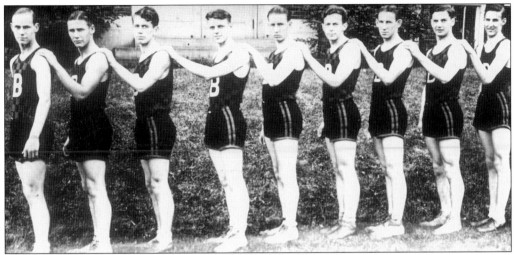

The 1929–1930 Bath High School boys' basketball players posed for their team picture.

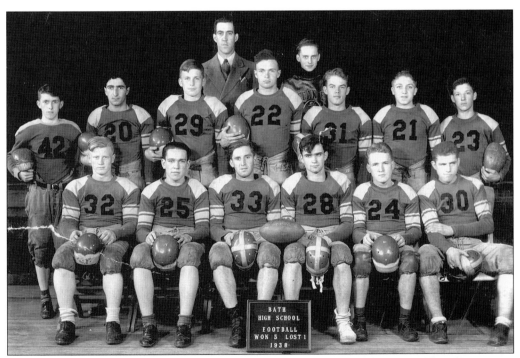

The Bath High School football team of 1938 won five games and lost one. The players were from left to right: (front row) Max Pierson, Ed Kohnle, Bill McPherson, Nelson Boyd, Les Barr, and Mike Strobya; (second row) George Cooper, A. Nemer, David Fox, Frank Mitchell, Pete Miller, Bob Crile, and Frank Fundak. Russell Milburn (left back) was the coach, and Bill Kramer was the manager.

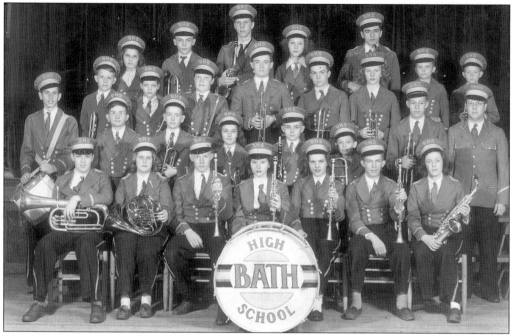

Pictured is the Bath High School marching band. No date is given for the photograph. Del Mar Graf (last person standing in the second row) was the director. He graduated from Baldwin Wallace. Dimit Brothers Photographers in Alliance, Ohio, took the photo.

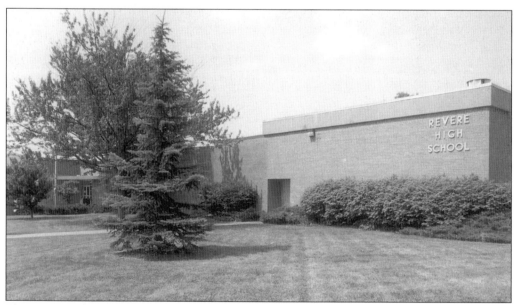

Plans to consolidate Bath and nearby Richfield school districts began in 1949. The new district would be called Revere. In order to consolidate, the school board proposed that while the new high school was being built, students should attend half a day at Bath School and half a day at Richfield School. Revere High School opened on Everett Road in Richfield in January 1953. This photograph shows how it looked after an addition in 1967–1968.

In 1953 Roy Pugh led the Bath and Richfield School Districts through a consolidation into the Revere School District and served as the first superintendent of the new district. He retired from that position in 1954, but continued to teach chemistry and physics at the high school until 1963. He and his wife, Ruth Alexander Pugh, owned and operated an antique store at Hammond's Corners. He was remembered as a dynamic leader. He died in 1978.

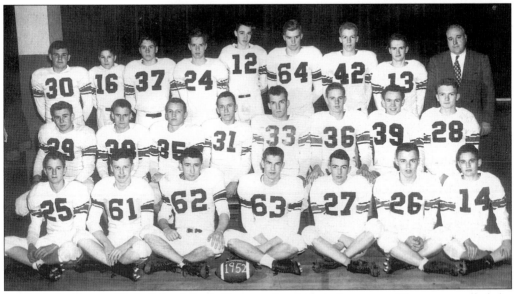

In 1952 the Revere High School football team played their first game. They were called the Minutemen and wore red, white, and blue. From left to right, they were: (first row) Mike Lewis, Homer Anderson, Frank Zodnik, Lawton Vaughan, Bruce Bleichrodt, Brian Showmaker, and Pete Dietrich; (second row) Richard Feiber, Carl Deitrich, Mark Spickard, Bill Moats, Bob Rumbaugh, Bill Brunskill, Jim Spangler, and Roger Schwing; (third row) Jim Klein, Larry Longfellow, Dick Stark, Buddy Liddle, Richard Howe, Fred Rice, Bob Wells, Don Cass, and Kermit Smulbach, coach. (*Photo Courtesy of the Richfield Historical Society, Richfield, Ohio.*)

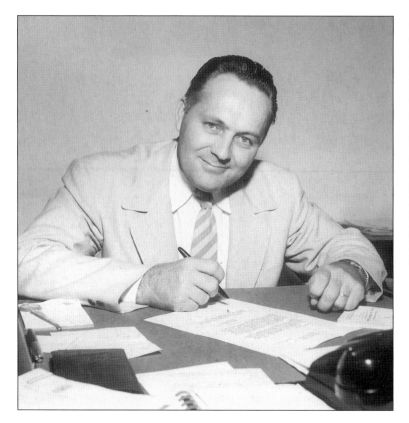

George Bayliss was the principal of Revere High School from 1954 to 1971. Harold Schweisberger served as Revere's first principal in 1953 before becoming superintendent of the combined Revere School District. (*Photo Courtesy of the Richfield Historical Society, Richfield, Ohio.*)

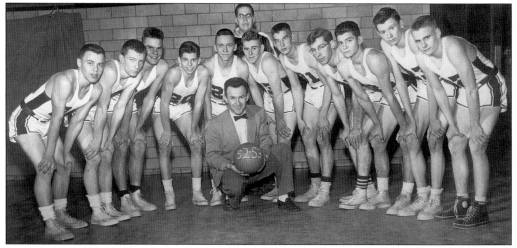

This was the 1952–53 Revere High School basketball team. The players were, from left to right: Brian Shoemaker, Fred Larson, Glenn Rand, Dick Stine, Bill Moats, Wayne Fischer, manager, Richard Feiber, Lawton Vaughan, David Dickson, Joe Schmidt, Gerald Hutchison, and Carl Dietrich. Coach Gordon Knapp holds the ball in the center. (*Photo Courtesy of the Richfield Historical Society, Richfield, Ohio.*)

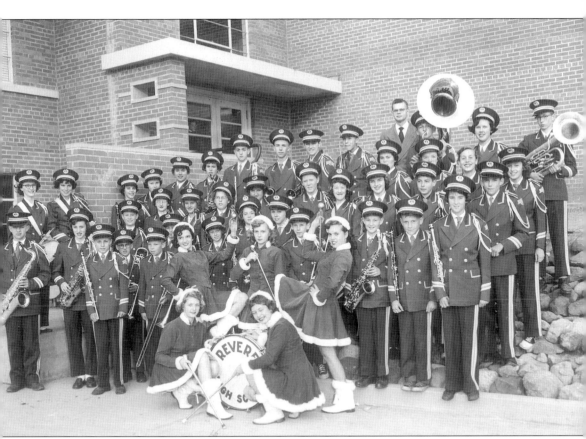

The Revere High School Band marched out onto the Minutemen's football field in 1955 under the direction of Robert W. Lutz. The musicians were from left to right : (kneeling) Nancy Bissell and Beverly Foky; (first row) Gordon Bayliss, Pat Holland, Hugh McDonald, Roger Cranz, Randy Belohlavek, Yvonne Dunlap, Karen Sylvester, Jackie Schneyer, Eric Weinrick, John Jackson, and Barbara Guckleburger; (second row) Sarah Benson, Sue Jackson, Larry Gray, Tim Selby, Jean Watson, Betty Guckleburger, and Becky Lightfoot; (third row) Judy Belohlavek, JoAnn Hobensack, Sandra Shoemaker, Barbara Hager, Nancy Coffee, Dianne Barber, Pat Schoner, Mary Willey, Olen Bleichrodt, and Dale Neuendorf; (fourth row) Linda Gray, Barbara Zitek, Mimi Jackson, Stanley Martin, Jim Burkett, Leroy Cranz, Gerald Burkett, Pat Gunion, Carol Martin, Pat Seibert, and Carol Paulett; (fifth row) Robert Lutz, George Schneider, Sharon Miller, and Tony Benson. (*Photo Courtesy of the Richfield Historical Society, Richfield, Ohio.*)

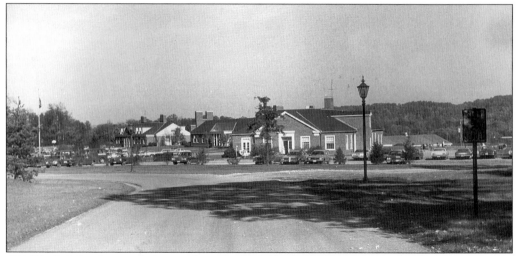

Old Trail School moved from Akron to Bath Township in 1967. This private school is surrounded by 55 acres of land and is adjacent to the Cuyahoga Valley National Park. (*Photo Courtesy of Old Trail School, Bath, Ohio.*)

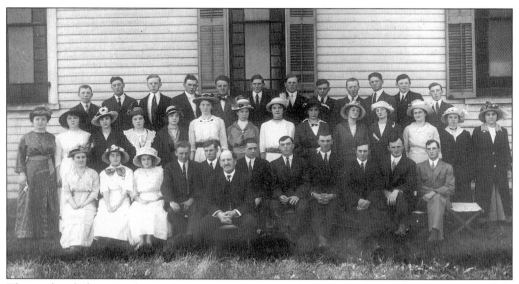

This undated photo is of an early congregation or Sunday school class at East Granger Disciple Church. Reverend Charles Searls of Hinckley was the pastor for many years. The Disciples Church was organized in Bath in 1832. The East Granger Church was built in 1860 at the corner of Medina Line and Granger Roads. Members died or moved to new churches after World War I, so the church finally closed in 1925.

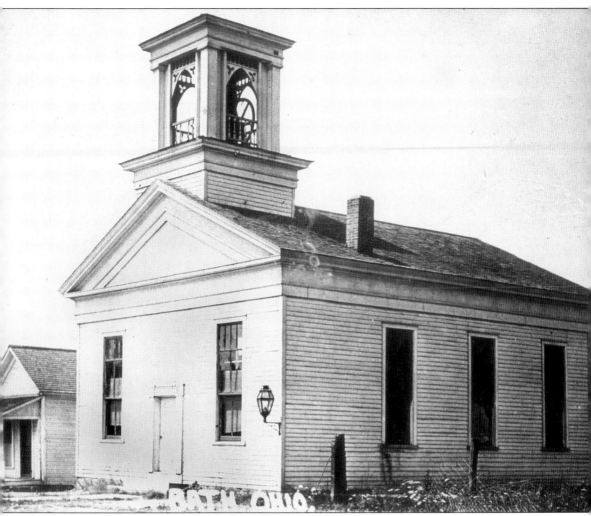

Bath Congregational Church originated in 1818 with Jason Hammond's family. Ezekial Williams deeded the land for a dollar to Hammond, John Holmes, and Moses Latta to build a log meeting house and cemetery on the northeast corner of Bath and Cleveland-Massillon Roads. Simeon Woodruff became the first permanent minister about 1823. Andrew Hale was an early choir director. The congregation outgrew their log building, and the above church was erected in 1834 in the same place. It was so structurally sound that it withstood three moves—one in 1870 after being converted to a town hall, one in 1898, and again in 1949 to its present location on W. Bath Road. The Bath United Church of Christ is still in use and has been added onto several times, including a $1.4 million fellowship hall. Today, it is one of the largest congregations in Bath. The cottage at the left was the home of a widow, Mrs. Mary Talcott.

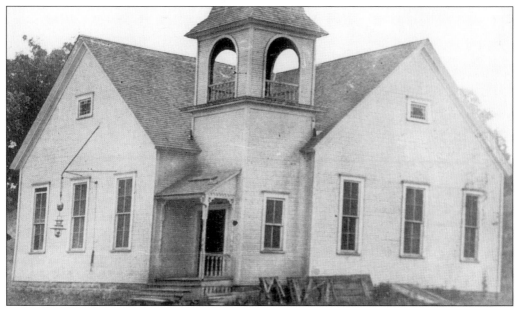

Ghent Church was built in 1901 after the Ghent Ladies Aid Society decided the village needed its own place of worship. Ghent Disciple Church, consisting of a small sanctuary, was built on land donated by Jared Barker on the corner of Cleveland-Massillon and Yellow Creek Roads. The belfry and vestibule were built in 1905. The bell was purchased that same year. The center of activity during baptisms, it drew people from Ghent and neighboring communities to witness converts being totally immersed in the Yellow Creek.

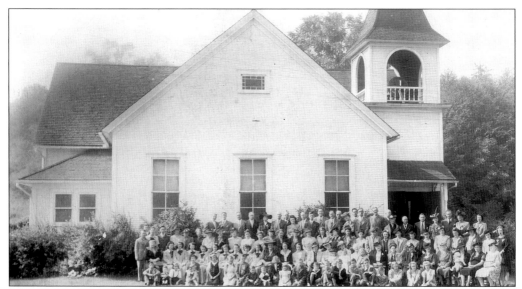

The congregation of the Ghent Church posed for this picture taken in September of 1944. To keep the children from continuously tolling the bell, Lon Alexander took over the job of bell ringer. As the children entered the church he gave each a piece of candy, thus he became known as the "candy man." In 1948 an educational/social wing was added. In 1960 the Ghent Christian Church moved to a new site on Granger and Crystal Lake Roads. The old church remains at its original location.

Five

DESCENDANTS

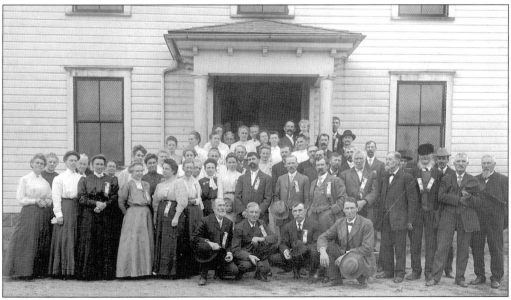

The Center of Bath Grange No. 1331 was established on February 8, 1889. Since it was a family organization, women were given equal standing with men, and a "junior grange" was available for children. Here, families belonging to the Grange are pictured in front of the Historic Bath Town Hall about 1908.

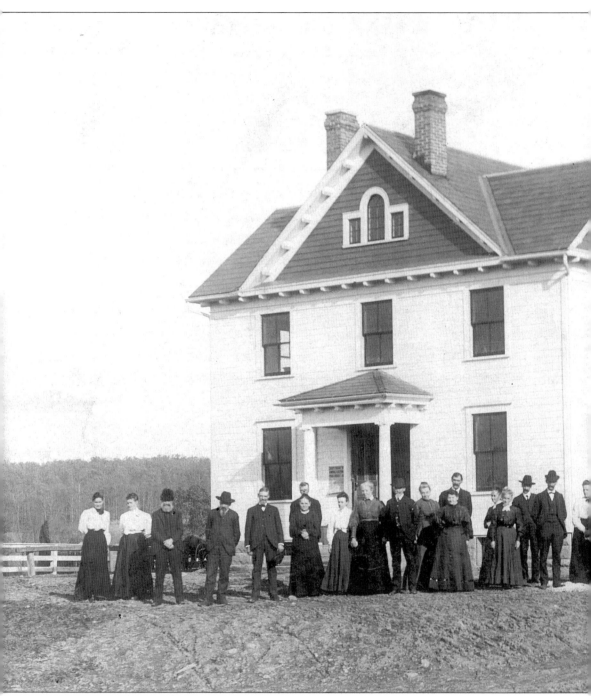

In 1905 members of the Center of Bath Grange No. 1331 posed in front the newly finished township hall at the corner of Bath and Cleveland-Massillon Roads. The little boy at the right is identified on the back of the photo as Jim Miller. Other names have been lost with time. Coal stoves heated the wooden building, which is sometimes referred to as the Grange Hall, and oil lamps were affixed to the walls for light. A raised section at one end of the main hall has been used as a stage. The second floor is an enclosed balcony which now houses the Bath Township

Historical Society. Renovations and improvements over the years have included electricity, a well, septic system, gas furnace, and concrete basement floor. The historic hall has been used for township offices, as well as for meetings of the Grange, boy scouts, girl scouts, Bath Volunteers for Service, and the Bath Community Players. Bath Town Hall still plays an active role in the community and is rented for parties and meetings.

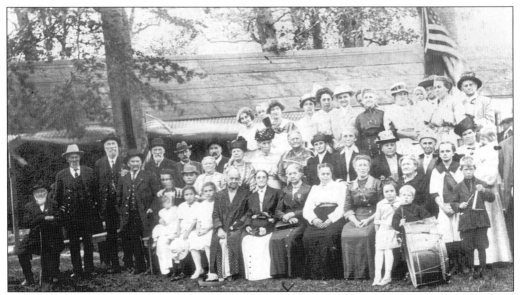

The Pioneer Picnic was held every September in Black's Grove at the corner of Hametown and Granger Roads. The picnic commemorated Admiral Perry's victory on Lake Erie. Jared Barker served as president for the picnic for over 50 years. Allie Fryman was secretary.

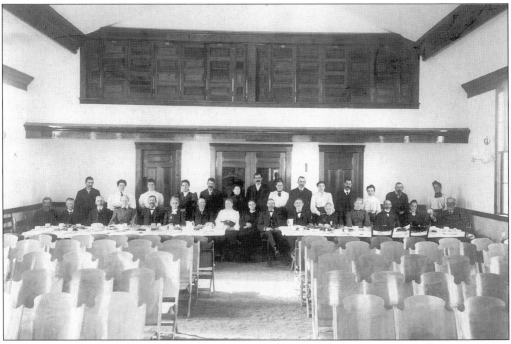

This photograph was taken when the Bath Grange moved into the new town hall on November 18, 1905. Ira Underwood was Master at this time. This view shows the enclosed, second-floor balcony, present site of the Bath Township Historical Society. The Grange was formed after the Civil War to unite farm families and educate them in an effort to raise their standard of living.

This is Ford Solomon Crile's 1920 graduation picture from the old Bath High School. He married Helen Hopkins four years later. They had six children known as the "Crile Indians" because they were raised on the 35-acre homestead on W. Bath Road. His career as Bath Township clerk from 1948 to 1967 was outstanding. He died in 1980.

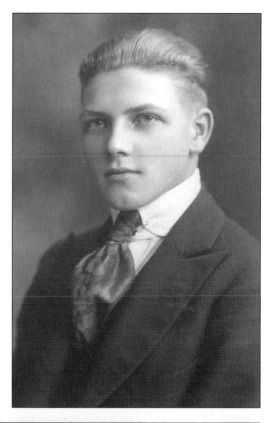

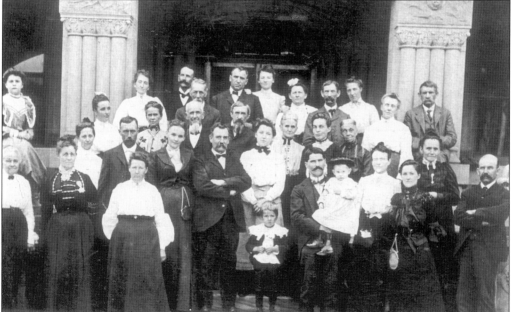

Jared Barker is pictured here (but not identified) with a few of his friends after he was elected Summit County Sheriff in 1902. He served four years. Angels at the top of the pillars on the courthouse were fashioned after his daughters, Bessie and Mary.

Bessie Hawkins, pictured here in a photograph taken at Christmas 1966, was the great granddaughter of one of Bath's first settlers. Her father, Jared Barker, was the Summit County Sheriff in 1902, Summit County Commissioner and the Head of Summit County Milk Producers Association in 1916. Bessie followed her father into public life by being active in the Republican party, a jury commissioner, and school board member. She was born in the Barker family farmhouse on Yellow Creek Road, where she later lived with her husband, Harry. The back of the photograph reads: *"To dear Wilma who has been so kind to this plump old bird. Ever love Bessie"*

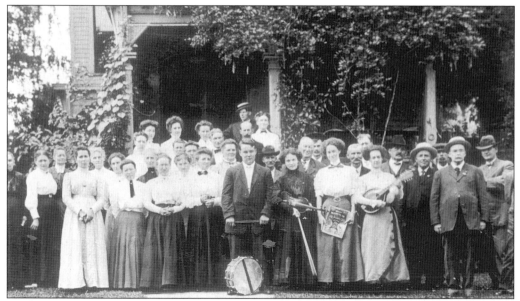

Pictured here is a gathering at the Davis farm, complete with musicians. There was no date on the photograph.

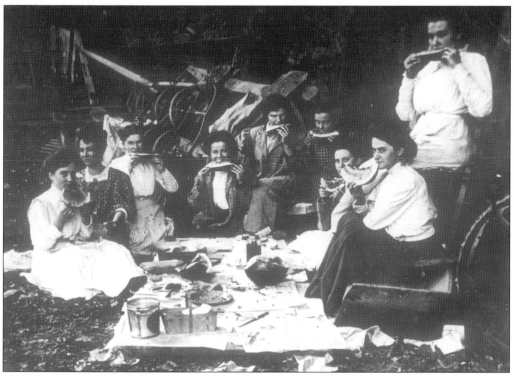

This photograph of Bath ladies at a watermelon picnic is undated.

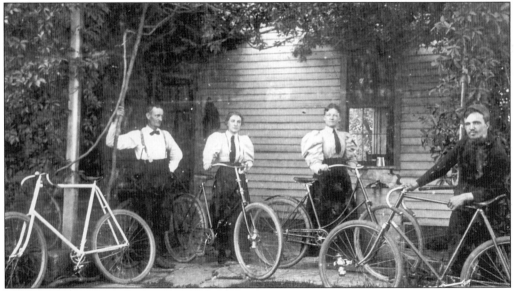

Cyclists posing for the camera are, from left to right: Edwin Bell Howe, his wife Cora Underwood Howe, Ann Harrington, and unidentified.

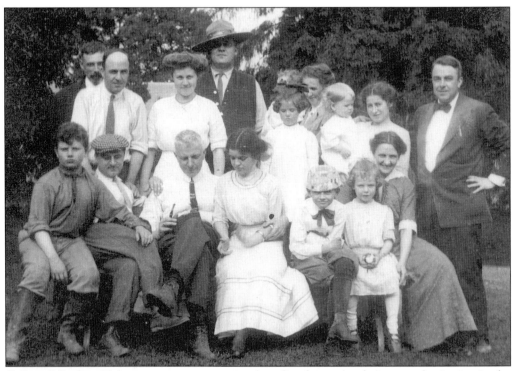

C.O. and Pauline Hale ran a summer vacation boarding house on their estate beginning in the 1880s. Hale met his guests at Ira Station and drove them to his home in a horse and buggy. Their visitors were the socially prominent of Akron and Cleveland, including the Seiberlings and Severances. Pictured here is Amos Englebeck (in the hat), a well-known attorney from Akron.

These are three of Wilhelm Schumacher's children. They lived in a house at Ira built by William Hale. The children are not identified. There is no date given for this image, but it is certainly earlier than the family photograph in Chapter 1.

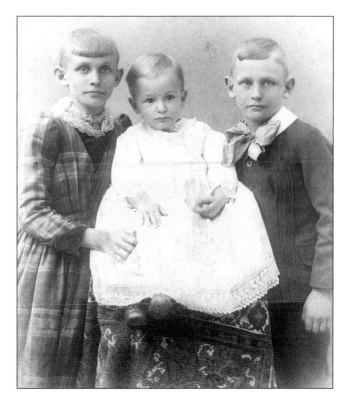

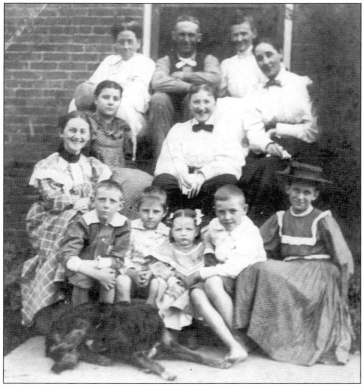

A group of boarders at Hale's posed for this photograph at the side of the house. Some of the summer boarders enjoyed the farm so much that they rented land from Hale and built their own summer cottages. Children especially loved the area. They swam in the creek that ran through the property, hiked in the hills, explored the woods, and slept out under the stars.

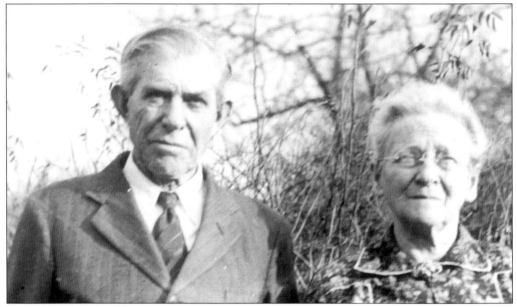

Eugene Cranz married Nettie Parker of Osborne's Corners in 1893. They lived on the Cranz farm, known as Pleasant Valley Farm, at Ira and had four sons and two daughters. Nettie died in 1939, and Eugene died in 1952 at age 89.

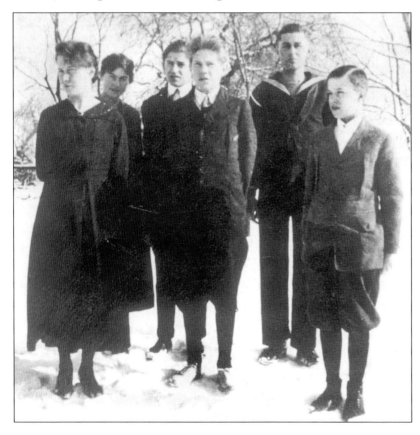

Eugene and Nettie Cranz's six children posed for this picture in the snow around 1918. Their names were, from left to right: Gracia, Doris, Damon, Harmon, Luman, and Paul.

From 1819 to 1865, Jim Brown was the chief of the most notorious and successful gang of counterfeiters east of the Mississippi. His charisma and good looks made him so popular among his neighbors at Ira and nearby Boston Township that he was elected Justice of the Peace. One of the three times he was jailed, he received a pardon from President Zachary Taylor. He was born around 1800 in New York and died near Yellow Creek in 1865 from a broken neck suffered in a fall on a canal boat.

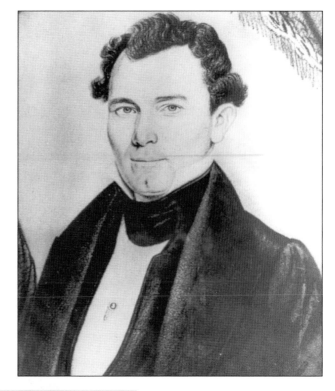

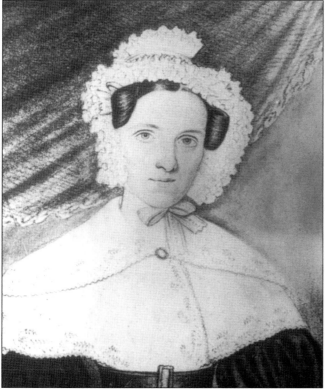

Lucy Mather Brown (1800–1884) was the long-suffering wife of Jim Brown until she divorced him in 1851. She lived in their house at Ira until her death.

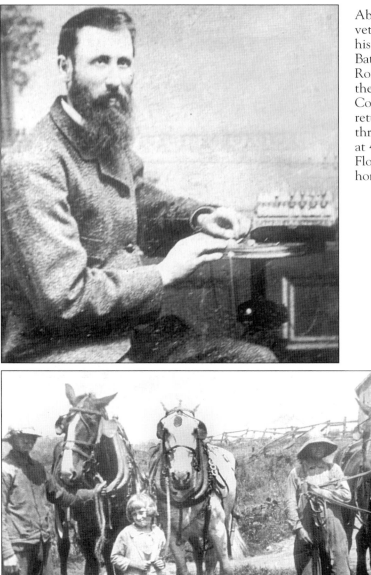

About 1877 Civil War veteran Harvey Smith left his farm on the corner of Bath and Medina Line Roads to study medicine at the Homeopathic Hospital College in Cleveland. He returned home to set up a thriving practice, but died at 44 from cancer. His son, Floyd, also became a homeopathic doctor.

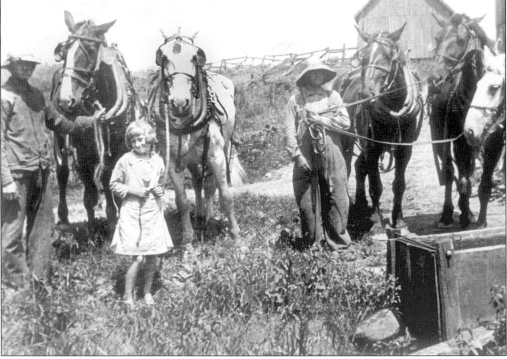

This photograph of the Fryman's Farm was taken in 1925. From left to right, the family members are: William, Alleen, and Rex Fryman. The water trough is said to have come from an old cheese factory.

Orpha Doolittle was the daughter of Lyman and Charlotte Hale Shaw Doolittle. She married Virgil R. Shaw on November 5, 1865. Her sister Jennie married Virgil E. Shaw. Orpha had three sons, Obed, Omar, and Odel. They lived on Hametown Road near Moore's Chapel Cemetery.

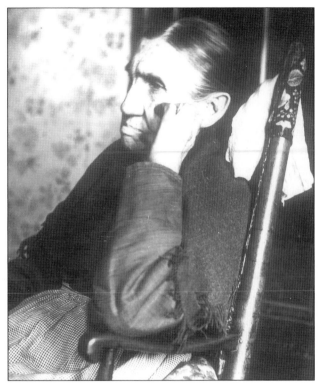

Donald Shaw, the grandson of Constant Shaw, lived in the 1832 home of Sylvester Shaw up into the 1950s.

Alleen Fryman Stein was the first president of the Bath Township Historical Society. As a descendant of the Hopkins, Millers, and Frymans, she was the perfect choice. The historical society came into being at Alleen's suggestion after the 1968 Sesquicentennial. She was born in Bath in 1918 and married Eddie Stein in 1948. In 1980 Stein deeded the Old Stony Hill Schoolhouse, which was on their property, to the Bath Historical Society.

Don Brown was one of the early developers in Bath. Meadow Park on Bath Road is one of his well-known developments of the late 1950s. Meadow Park was at one time Wellworth Farm.

This photograph was taken in 1945 of brother and sister Don and Phyllis Crile at Redgate Farm on Bath Road. The Crile's are descendants of Isaac and Susan Harrison Hopkins who arrived in Bath by ox cart in 1813.

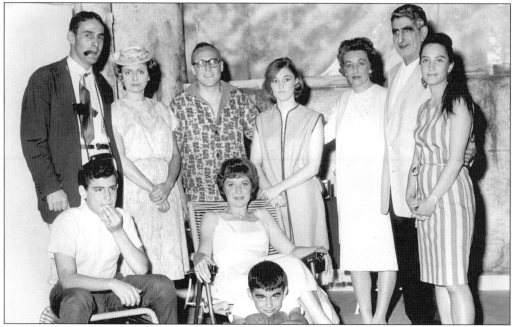

Bath Community Players presented *Time of the Cuckoo* by Arthur Laurents at the Bath Town Hall in October of 1963. The cast members were from left to right: (seated) Randy Scherr, Ester Marshall, and Glen Kerkian (little boy); (standing) Willard Berrare, Judy Draffan, Bill Wenum, Mary Beth Hess, Lou MacDonald, Aran Kerkian, and Jane Ann Turzillo. Rice A. Hershey, Jr. directed. The curtains went up on the Bath Players for the first time in 1958. In 1959 they established the Alan MacCurdy Award, given yearly to an outstanding senior Thespian at Revere High School.

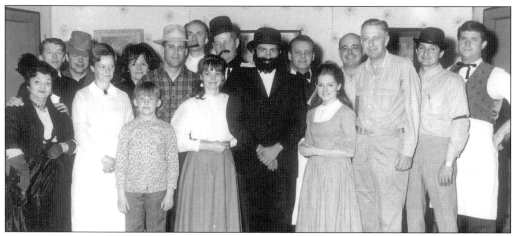

About 1968, the Bath Community players presented the melodrama *Dirty Work at the Crossroads* by Bill Johnson. The director was Bonnie Weber, and the producer was Dave Griesmer. The performers included from left to right: (first row) Alva Banker, Nonie McGarry, Rusty Frese, Bev Alessio, Don Paddock, Kathy Lucas, Bill Lloyd, Reno Alessio, and Ed Boss; (second row) Chuck Hildreth, Phil Hershey, Dee Allick, Bruce Doolittle, Nick Roetzel, Glenn Frese, Gordon Tibbs, and Ken Fobes. It was one of the first productions at "The Barn," a building the players acquired and turned into a theater.

The Bath Fire Department was formed in February 1945. In September of that year, the township trustees appointed Ross Duncan as the first fire chief. He had a roster of 30 volunteer firefighters. Duncan served until 1949. Stony Hill Fire Department, formed in 1937 with 22 volunteers, preceded the BFD.

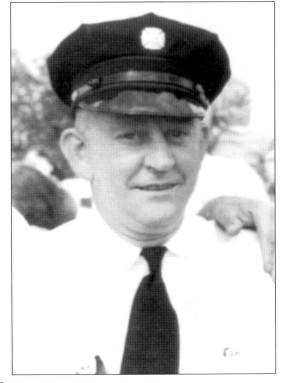

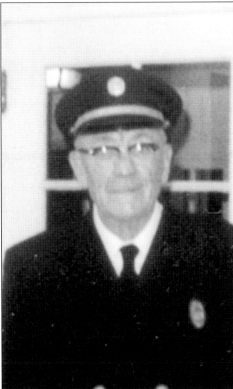

Don Kramer was appointed fire chief in March of 1949. He retired in 1954. During this time, the township built a new station at Bath and Cleveland-Massillon Roads, established mutual aid with the Akron Fire Department, bought a replacement tanker, and hired the first two full-time firemen.

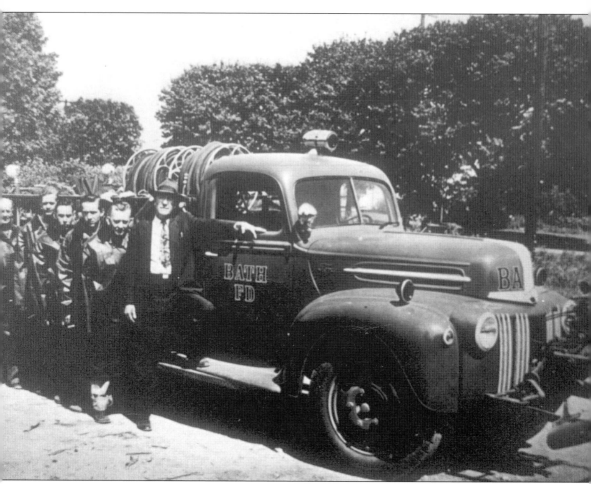

Bath Fire Truck #1 was built on a 1945 Ford chassis. Firefighters posing with the truck are from left to right: Howard Young, R. J. Keifer, Cecil Miller, Larry Hershey, Don Kramer, and Chief Ross Duncan.

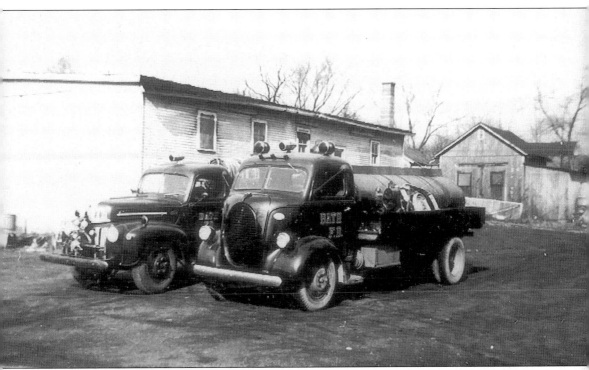

The first Bath Fire Department's tanker (right) was purchased shortly after the department organized in 1945. The snub-nose 1939 tanker from Penzoil carried approximately 1200 gallons of water. The truck was kept in Fireman Clarence Brock's garage in Ghent. Fire Truck #1 is on the left.

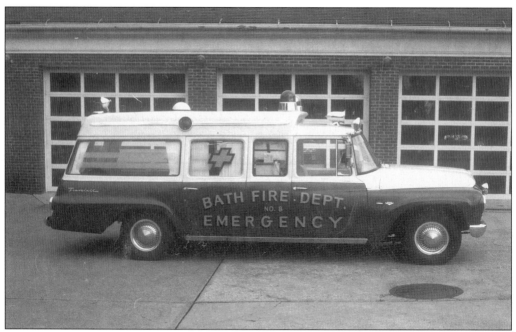

In 1965 the Bath Fire Department purchased this 1966 International Harvester ambulance. It was the second ambulance to join the fleet. The rescue squad began operations three years earlier when the department converted a 1962 step van into a rescue vehicle and all members were trained as emergency medical technicians.

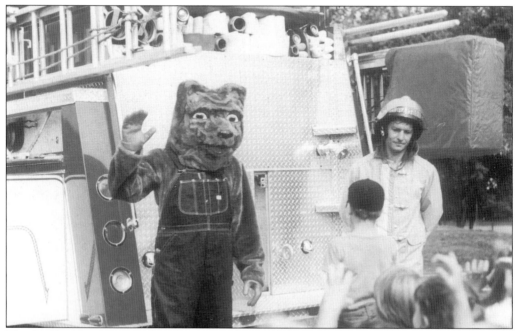

The fire department's Smokey the Bear (Glenn Goodrich) and Gordon Hartschuh visited the children of Safety Town, which was formed in 1970s. Hartschuh became fire chief in 1992 and served until 2001.

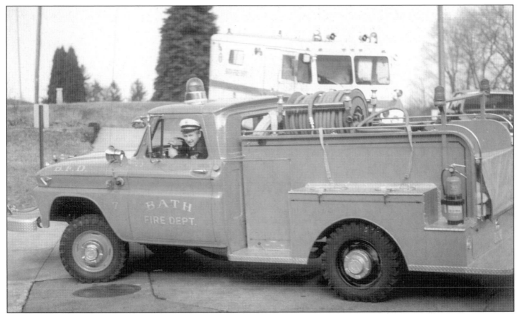

This 1964 GMC, known as Truck #7, was donated to the Bath Fire Department by Raymond Firestone. Its primary use was to attack grass fires. Today, it is used mostly for parades and at the horse show. The driver is Larry Hershey, fire chief from 1964 to 1992. As a teenager in 1945, he was one of the founding members of the department and would be excused from school classes to fight fires when the sirens sounded.

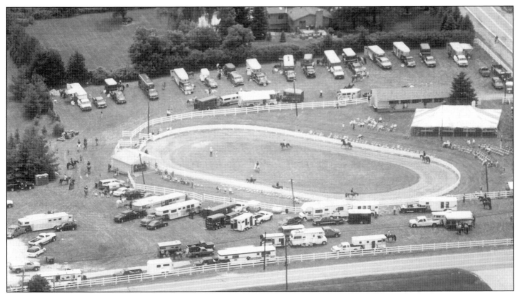

The Bath Horse Show began with children in Bath Riding Club in 1944 at the Whetmore Barn in Ira. A few years later, the show moved to Harold Thompson's Hill Top Farm. The fire department took over in 1947 with the help of "Bus" and Jean Gladwin. The proceeds went toward equipment and training. In 1972, the show was moved to the horse show grounds pictured above on Everett and Revere Roads. It is the oldest horse show in the Central Ohio Saddle Club Association circuit.

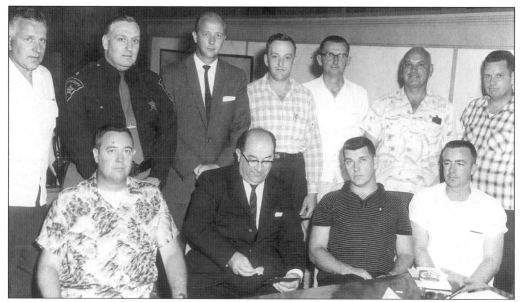

In 1961 several Bath Township men volunteered to form the Bath Police Department. They were sworn in as constables and given $50 for uniforms and equipment. They used their own vehicles to patrol and answer calls, bought their own gas and used CB radios to communicate. The men posed for this 1963 photograph when they were sworn in as Summit County Sheriff's deputies. They are from left to right: (front row, seated) Bob Cole, unidentified judge, Gail Epling, and William Gravis; (second row, standing) Leo Main, Sheriff Robert Campbell, Bath Township Trustee John Warner, Harold Egbert, Dick Lite, Nate Hensel, and Roy Carr.

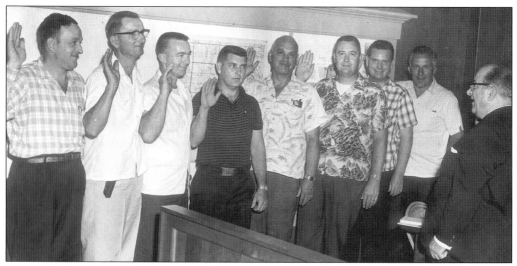

In 1963 Bath Township trustees and Summit County Sheriff Robert Campbell signed a contract making the Bath Police Department a division of the sheriff's office. This photograph taken on June 12, 1963, shows Bath officers being sworn in. The new deputies were from left to right: Harold Egbert, Dick Lite, William Gravis, Gail Epling, Nate Hensel, Bob Cole, Roy Carr, and Leo Main. The judge is unidentified. Epling and Gravis were hired part time. Carr was the first part-time chief (1963–1964). Cole followed Carr as second part-time chief. Gravis went on to be the second full-time chief (1979–1994).

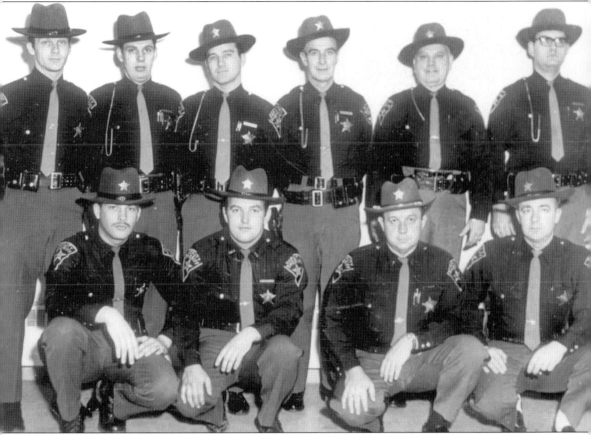

The four men in the front row of this 1967 photograph were full-time officers dressed and dispatched by the sheriff's department and paid by Bath Township. They are from left to right: Jerry Williams, Ben Ferguson, Bob Ferguson, and Bill Gravis. The men in the back row were part of the volunteer sheriff's posse, or horse patrol. The first three men on the left are unidentified. The others from left to right are: Bill Price, Nate Hensel, and Earl Hensel.

In 1968, when the sheriff's department wanted to raise the cost of its contract with the township, the trustees designated Bath as its own police district. Bob Ferguson was the first full-time chief. He served from 1967–1979. A modern form of police communications system came about under his leadership, as did the cadet program and Safety Town. He was also responsible for the golf outing, which raised funds for the department.

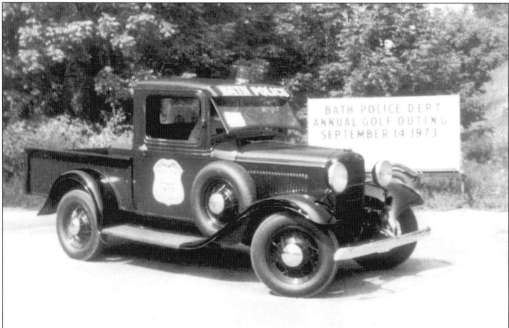

This truck was purchased with proceeds from the golf outing. The photo was taken in 1973, but the truck purchased earlier.

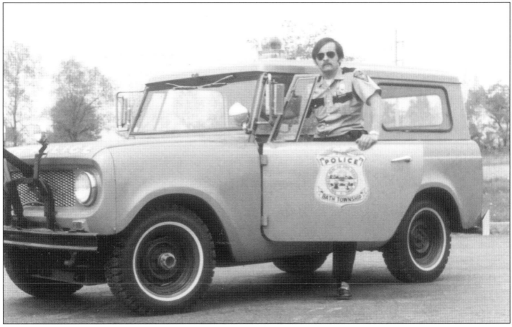

This four-wheel drive vehicle was purchased by the police department around 1970. It was used for winter patrol on the country roads of the township. The officer pictured is Dennis Kemper.

C. Robert Cole was the second police chief in the township. He served part time from 1964–1967.

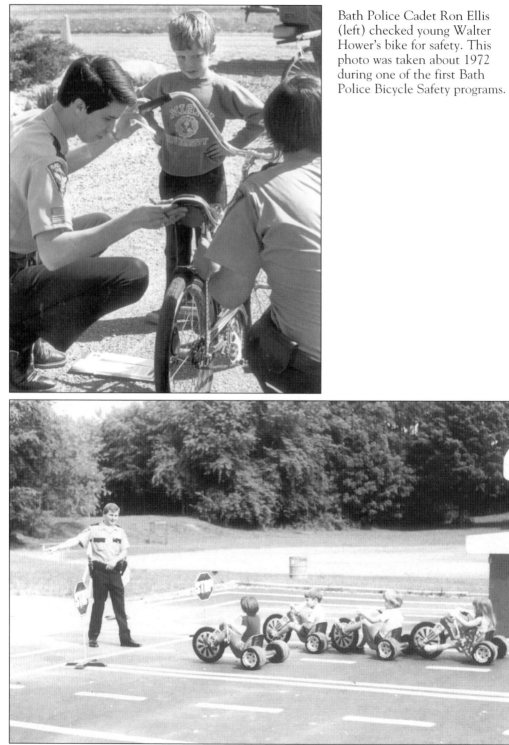

Bath Police Cadet Ron Ellis (left) checked young Walter Hower's bike for safety. This photo was taken about 1972 during one of the first Bath Police Bicycle Safety programs.

Officer Rich Munsey taught pre-school children at Safety Town. The children learned about traffic, crossing streets, keeping themselves safe, and calling the police and fire departments.

Six
SCENES

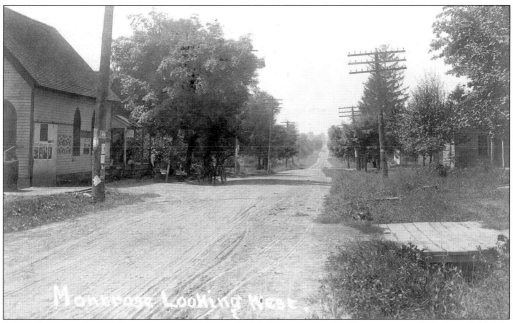

This photograph of Montrose was taken in 1914. The view is looking west on Medina Road. It is a post card that was sent to Miss Gladys Tompkins in Akron postmarked Copley, February 25, 1915. The message reads "Best wishes of your Friends," and is signed Mr. and Mrs. E.A. Hawkins.

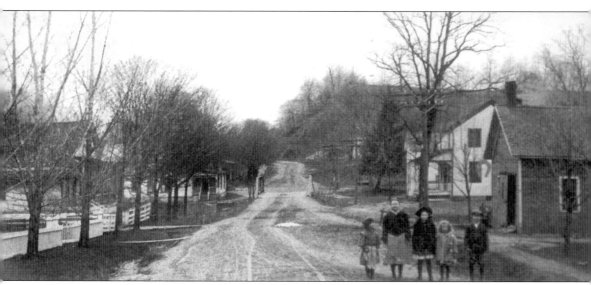

This scene was Wye Road at the corner of Yellow Creek Road looking north from Ghent Village in 1914. The little boy at far right was Ford Crile. At the right was Sherm Miles Blacksmith Shop. Behind it was the Harry Crile residence. The house on the left was built by Frank Pierson. Behind it, the front porch of Ghent store can be seen.

The children in this image may well be the same ones as in the previous photo. Taken at Ghent, the photograph looks west on Granger Road. Ott Hershey's store is at the left.

Starting in Medina County, Yellow Creek flows west to east and eventually empties into the Cuyahoga River at Botzum. The course of the stream in Ghent is about eight miles long. A 400-foot fall made the Creek a perfect source for waterpower. Yellow Creek supported at least 13 mills at one time or another.

This image shows some of the destruction from the Flood of 1913 in Ghent near the bridge on Granger Road. The Freeman home is in the background.

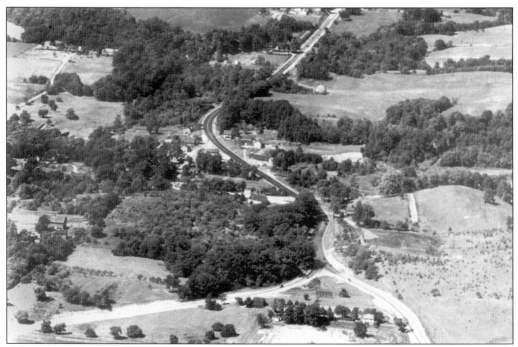

An aerial view of Bath looking north shows the Y where Cleveland-Massillon and Ghent Roads converge. The photo predates gas stations and restaurants.

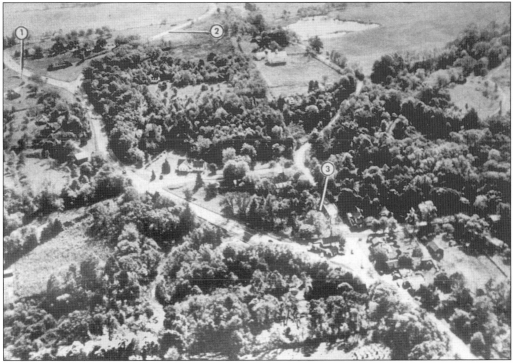

This photo shows the triangle in Ghent from the air. Looking south: number 1 is Ghent Road; number 2 is Cleveland-Massillon Road; and number 3 is Wye Road at the Yellow Creek bridge.

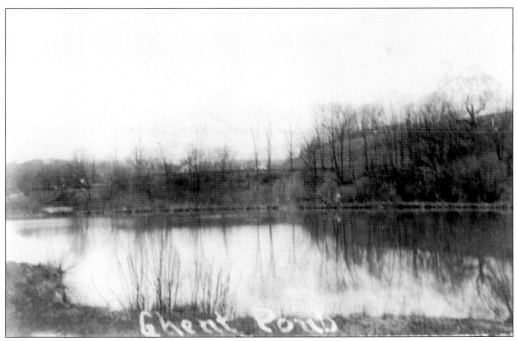

Ponds stored water from Yellow Creek to help power the mills. This one belonged to Ott and George Hershey. It is no longer in existence.

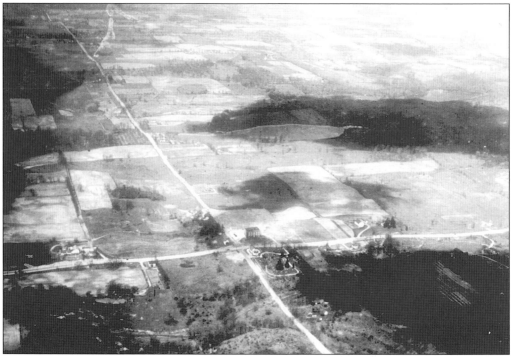

Here is an aerial view taken about 1955 looking west over Bath's open spaces. The main roads are Cleveland-Massillon and Bath.

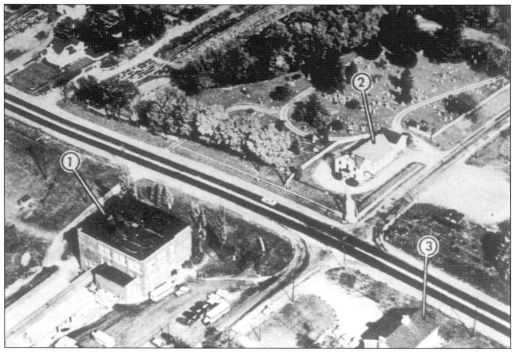

An aerial view of Bath Center, probably taken in the 1960s, shows: 1—Bath School; 2—The Historic Bath Town Hall; and 3—Bath Fire and Police Station.

This was Route 18, once called Smith Road, at Stony Hill as it looked in 1939. The photo was taken about a mile west of Interstate 77 on Medina Road.

This photograph, taken in 1925, looks northeast on Route 21, Cleveland-Massillon Road.

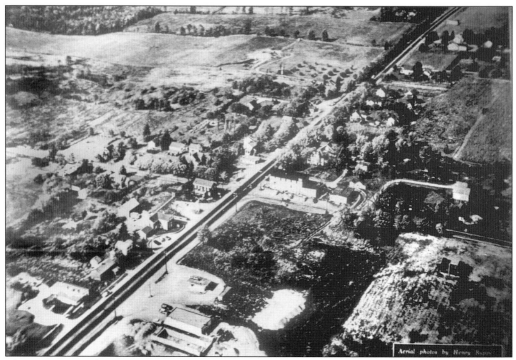

This is an aerial view of Hammond's Corners looking northwest. Near the center of the photograph is the crossroads of Cleveland-Massillon and Ira. Garth Andrews' store can be seen. This photo was taken before 1970.

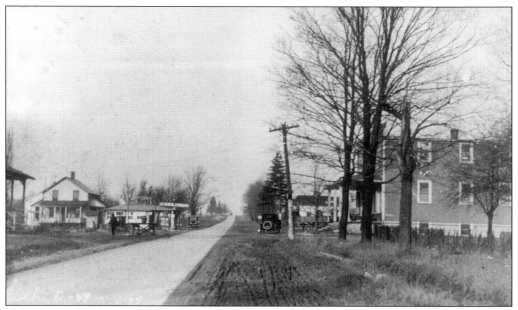

This photo of Hammond's Corners looks north on Cleveland-Massillon Road. At the right is the rebuilt Whitcraft's Store. The porch at left is that of the Landmark Inn, and the house in the distance is probably where Bath School Principal Roy Pugh lived.

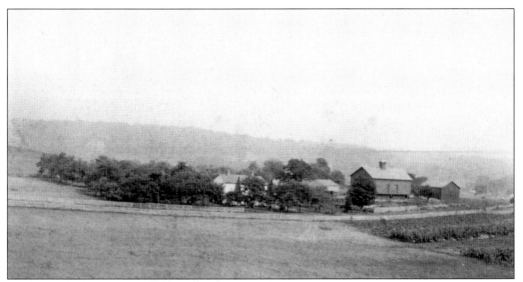

This photo was taken in 1887 of the Cranz farm at Ira. The house and barns still stand and are now owned by the Cuyahoga Valley National Park.

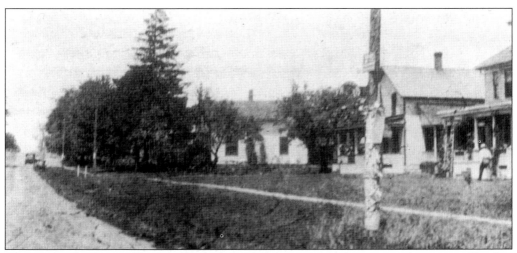

This is Cleveland-Massillon Road looking north from Hammond's Corners about 1918. The first house from the right belonged to Sigel Whitcraft; the second house was a cheese factory moved from Ira Road; and the third building was originally an old school house dated 1903 or earlier.

This is a view of Ira Road from in front of Kate Cranz's house in Ira.

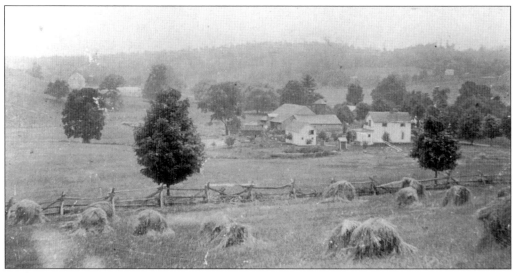

Carl Cranz's farm was east of C.O. Hale's homestead.

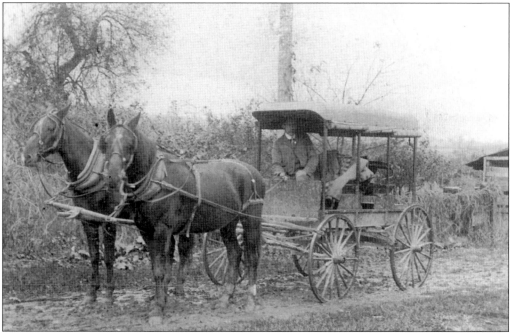

This carriage and horses were photographed behind the post office at Ira. C.O. Hale may be the driver. (*Courtesy of the Peninsula Library and Historical Society, Peninsula, Ohio.*)

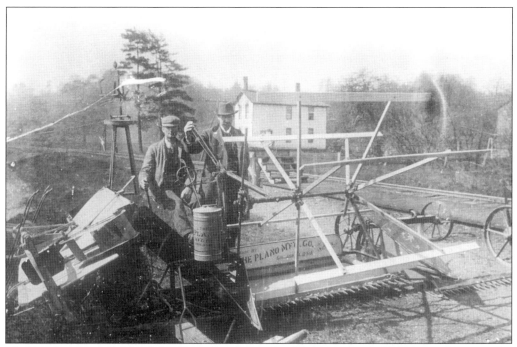

This binder was in front of the Howe farmhouse for this photograph. The post office is in the background.

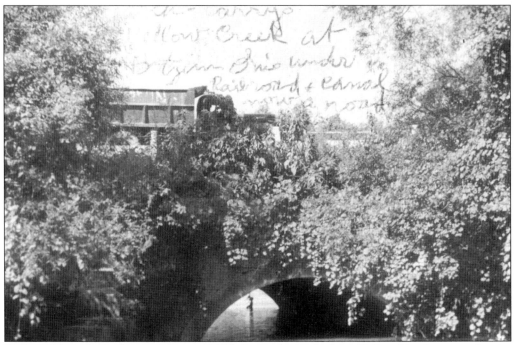

Richard Howe built this aqueduct in 1825. It was located where Yellow Creek ran under the canal and railroad on Riverview Road at Botzum.

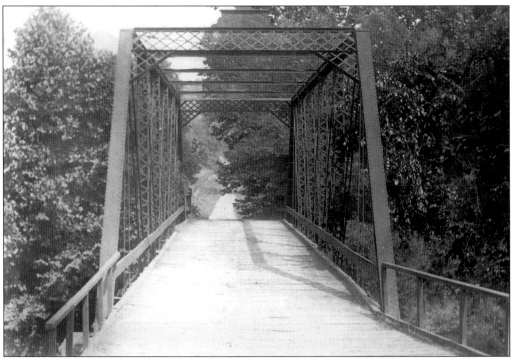

This bridge headed east on Ira Road crossed the Cuyahoga River at Riverview Road. Ira Train Station was off to the left of the bridge.

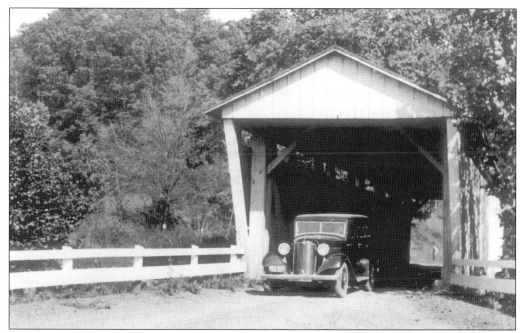

The Everett Road covered bridge over Furnace Run was built in the 1870s. The bridge is in Peninsula, but close to the Ira line, and travelers between the two settlements used it frequently. This photograph was taken 1930–1935 from the west end of the bridge looking east. The car belonged to John Ozmung of Peninsula. (*Courtesy of the Peninsula Library and Historical Society, Peninsula, Ohio.*)

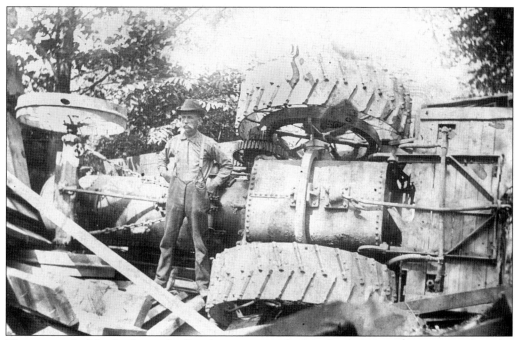

The east end of the bridge on Ira Road gave way under Mr. Snider's steam engine. Snider, who was from Richfield was not hurt. He righted the machine and drove it out.

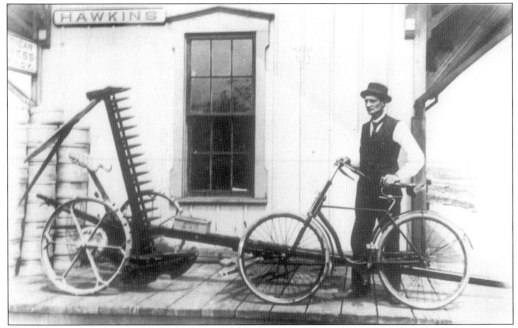

Ed Howe posed with his bicycle beside Ira Station. At left are cheese boxes from a cheese factory just north of the station, ready to be shipped out. The piece of farm equipment is waiting to be picked up. The photograph was taken in the late 1890s to the early 1900s. (*Courtesy of the Peninsula Library and Historical Society, Peninsula, Ohio.*)

The Bath Garden Clubs placed this sign on the grounds of the Historic Bath Township Hall. Similar signs were posted on all the boundaries leading into Bath Township. The signs were made around 1960.